IMAGES
of America

FRUITA'S HISTORIC MOON FARM

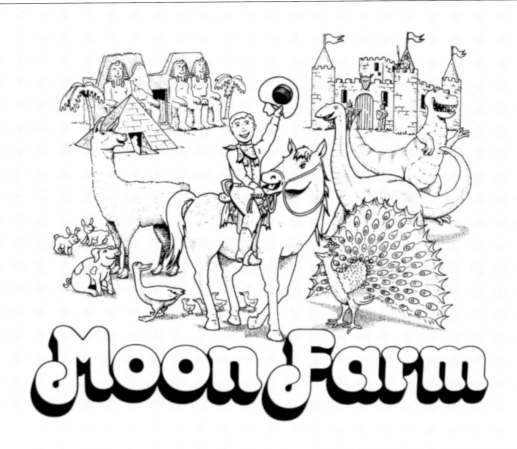

Moon Farm Logo. The Moon Farm logo was designed by an artist in the mid-1980s. It highlighted elements of Moon Farm. The Pyramid, Egyptian Temple, Spanish Castle, and dinosaurs symbolized buildings on the Moon Farm property. Various animals show the petting zoo aspect, and the boy riding a horse represented pony rides. This logo was used on T-shirts and for advertising. (Courtesy of the Moon family.)

On the Cover: Moon Farm day campers are shown passing by the Swiss Chalet as they return from a trail ride. (Courtesy of the Moon family.)

Images of America
Fruita's Historic Moon Farm

Jannae Moon

Copyright © 2023 by Jannae Moon
ISBN 978-1-4671-0985-7

Published by Arcadia Publishing
Charleston, South Carolina

Printed in the United States of America

Library of Congress Control Number: 2023931835

For all general information, please contact Arcadia Publishing:
Telephone 843-853-2070
Fax 843-853-0044
E-mail sales@arcadiapublishing.com
For customer service and orders:
Toll-Free 1-888-313-2665

Visit us on the Internet at www.arcadiapublishing.com

In memory of Wallace and Ella Moon

Contents

Acknowledgments 6

Introduction 7

1. True Pioneers 11
2. The Early Days 25
3. Dreaming and Building 39
4. Fun on the Farm 67
5. Day Camp Life 83
6. Later Years 115

Acknowledgments

First and foremost, I would like to remember Wallace and Ella Moon. Without their heart for children and dedication to the community, there would not be a book to write. I want to recognize my husband, David, for his patience, encouragement, and invaluable input into this endeavor. Thank you to my sister-in-law, Mary Joan (Moon) Seal for meeting with me several times along with reading my rough draft for correct information. I also appreciate DiAnn (Moon) Schuler, Mary Joan (Moon) Seal, Mike Moon, and their families for allowing me to share Moon Farm in this pictorial history. Thank you to the Workman sisters (Renee, Talitha, Paula, and Jana) for being a big part of Moon Farm while sharing stories and pictures. I also appreciate the Curfew families, especially Ed, Maxine, Cara, and Mariah.

A special thank-you goes out to my parents, Bert and Paulette Jens, for their continued support. I am grateful for the encouragement and input from my daughters, Taryn Moon and Brittany (Moon) Labor along with editing help from my son-in-law Nick Labor. Thank you, Ron and Brendon Jens, for sharing your memory book.

I would also like to mention Denise and Steve Hight, the authors of two Arcadia Publishing books, for their consultation. Thanks are due to Michelle Fuller with Uintah County Regional History Center (UCRHC), who assisted in locating photographs for chapters one and two. Gratitude is extended to Arcadia Publishing for allowing me to publish the story of the historic Moon Farm.

Finally, I would like to thank every friend, visitor, and day camper that visited Moon Farm at one time or another. Without you, the memories would not exist.

Fruita's Historic Moon Farm is meant to highlight the history of the founders in relation to Moon Farm and evoke memories for the reader. I apologize for any inconsistencies in stories or dates, as I interviewed several family members, used Ella Moon's notes, and researched newspaper articles. I found recollections, and dates do tend to vary.

Unless otherwise noted, all images appear courtesy of the Moon family.

Introduction

A sign at the entrance to Fruita's Historic Moon Farm reads, "A Place for the Whole Family to Enjoy." This was Wallace and Ella Moon's motto when they established Moon Farm north of Fruita, Colorado, on the 80-acre farm they purchased in 1954.

Wallace and Ella, born in the early 1900s, were pioneers in the state of Utah. Both lived in log cabins and attended one-room schoolhouses. Wallace farmed using a team of horses and horse-drawn farm implements. When Ella was five years old, her family moved across the state in a covered wagon. Coincidentally, these early experiences have been re-created and preserved at Fruita's Historic Moon Farm.

The Moon Farm adventure started with Ella's idea of keeping her seven-year-old son Mike busy by building a *Swiss Family Robinson*–inspired treehouse. Wallace helped after work and taught Mike the art of carpentry. When the treehouse was completed, Ella found old desks from a nearby schoolhouse. That sparked her next idea. The following year, Ella decided she would enlist Mike to help her build a little red schoolhouse. It was the perfect project, since Ella attended a one-room schoolhouse as a child and wanted one in her backyard. Wallace was at work, so Ella gathered what materials she could find and even bought wood (called seconds-cheaper wood) in Fruita. Of course, Wallace had to help with the project in the evenings and on weekends. However, he did not mind, because he loved carpentry and thought Ella's ideas were wonderful. After those early days, Ella envisioned dozens of other playhouses and museums for schoolchildren to enjoy. A few examples are a log cabin, a Dutch house, Spanish castle, a Native American area, and an Egyptian temple. Ella dreamt of a playhouse, building, or museum, and Wallace built it. After it was built, Ella took over again by using her talents to decorate and paint murals. She also added antiques to fit the themes. Today, there are over 30 playhouses and museums built by Wallace with the help of his and many other children.

Wallace and Ella had always loved children and adopted seven from Catholic Charities: Earl, Mary Joan, Mike, David, DiAnn, Nick, and Anna. When their son David was in kindergarten, he invited his classmates to Moon's Farm for a field trip—this was in 1965 and among the first field trips in the Grand Valley. Each year, more kindergarten teachers brought their classes to Moon's Farm for a spring field trip. Over the years, kindergartens from DeBeque, Parachute, Rifle, Delta, Montrose, Paonia, and other surrounding towns have also enjoyed a day at Moon's Farm. Word spread, and preschools and other elementary grades started booking field trips. The children would say they were going to Moon's Farm. Eventually, the name was shortened to Moon Farm. Kids on field trips have been experiencing Moon Farm for 57 years.

Visiting children loved to pet baby farm animals in the barnyard. There were usually baby chicks, bunnies, goats, sheep, and calves in addition to Wallace's horses. In the early days, people even donated non-farm animals. David remembers a raccoon, skunk, and baby coyote being on the farm at one time or another. However, the Moons soon realized they did not want to become a zoo and stuck to farm animals.

Wallace and Ella also hosted people at the farm. In the early days, if someone drove by and became interested in the little red schoolhouse, treehouse, or tepee built on the property, Ella invited them in. This gave her the idea for picnics and tours at Moon Farm. Sometimes, other members of the Moon family might head out to the backyard and find a surprise; unbeknownst to them, Ella had welcomed people passing by to picnic on the back lawn. Wallace said it was not out of the ordinary to return home from church on a Sunday morning and find people in their yard. Of course, the visitors were always greeted with enthusiasm, and many became friends. Thousands of families have toured the farm or had a picnic on the back lawn over the years. Examples of more organized gatherings are adoption day picnics, church picnics, birthday parties, company parties, and visitors touring. One of the visitors happened to be a licensed preschool teacher named Sandy Patterson. She and Ella thought it would be fun to host a daycare at Moon Farm. Hence, the day camp began. It did not matter that Wallace was 64 years old, because the Moons never planned on retiring.

Moon Farm day camp ran for 32 years, from 1976 to 2008. For the first two summers, the farm was leased to Sandy Patterson. Wallace and Ella worked for her and learned about running a daycare facility. The Moons took over in the third year, which was the summer of 1978. Spring Break Day Camp was added in the 1980s. An average of 150 kids per day—ranging in age from 5 to 12—attended day camp in the summertime. The farm was licensed for older children, too, and they were day campers in the early days. Later, there were only a select few teenagers; they were called junior counselors. State regulations required 1 counselor to 15 children. Therefore, Moon Farm hired 10 to 15 counselors each summer. Most were family members and friends. The year 2008 brought change. After 32 successful years of running the day camp, it was time to move on. Wallace had passed away in 1995, and Ella turned 90 years old that March. Although she wanted to continue running the day camp, a decision was made to retire it.

After 2008, since the day camp was no longer running, people assumed Moon Farm was closed even though David and Ella still hosted spring field trips, visitors, and birthday parties. Without the day camp, the farm was not generating enough money to keep it going. David had envisioned a pumpkin patch at Moon Farm. He was hoping that idea would save the farm. He thought people would come in October to enjoy the buildings and petting zoo and to purchase pumpkins. In the summer of 2011, David's idea was put into motion. The pumpkin patch was an immediate success, and the farm was saved.

Weekdays in October were normally booked with preschool and kindergarten field trips. The children explored all of Moon Farm, including the petting zoo and the haunted attractions, and received a small pumpkin. David drove the tractor with a hay wagon full of children to the kids' patch. He usually gave them a short talk about pumpkins and let them choose one to take home. A few teachers brought their classes to Moon Farm for a spring and fall field trip, while others chose one of the two seasons. Fall was getting busier and busier with the schoolchildren visiting.

Families also visited the pumpkin patch, with evenings and weekends being the most popular times. Some people wanted to grab a wagon, stroll through the patch, and pick their perfect pumpkin. Others appreciated the whole experience, which included the lower haunted areas and upper museums. Of course, families always lined up for the petting zoo and hayrides.

Ella enjoyed the first two years of Moon Farm's pumpkin patch before she passed away at the age of 95. Family members gave her golf cart rides to the fields during the growing season. Ella liked checking on the progression of the pumpkins. During October, she sat by the Swiss Chalet while visitors played around the farm. She also loved chatting with friends who ventured out to see her. She always kept a chair next to her, and it was not empty very often. One of Ella's favorite sayings was that everyone had a story. She loved listening to others' stories while also sharing her own.

David and Mary Joan, along with David's wife, Jannae, managed the farm and ran the pumpkin patch from 2011 to 2019. However, help was hired as needed. Friends and family members who wanted to be involved were also welcomed.

Since the nonprofit Grand Valley Equine Assisted Learning Center (GVEALC) planned to purchase Moon Farm, the Moons helped with the group's fundraising and taught volunteers the workings of the pumpkin patch in 2020. GVEALC bought the property in July 2021. David and

Jannae decorated for the 2021 pumpkin patch, and GVEALC took over that year during the month of October. The 2022 pumpkin patch was entirely managed by GVEALC. The nonprofit plans to maintain the pumpkin patch tradition.

Moon Farm also offered the perfect place for a vacation rental. The Moon family came to this realization after Ella passed away in 2013. Since the farmhouse stood on the property, it could not be sold separately. Why not invite people to the farm and allow them to rent Wallace and Ella's farmhouse? Fruita Crash Pad took charge as the property manager at the beginning of this endeavor. A few years later, David and Jannae became the property managers. Since 2013, the Moons have hosted groups from all over the United States and even Europe. The original plan was to accommodate mountain bikers, since the 18 Road trails were close by. As word spread, various other groups also started booking at Moon Farm. Memorable parties included mountain bikers, family reunions, hunters, dirt bikers, weddings, and businesspeople. David even hosted a new bike product launch for Rocky Mountain Bikes. Every year, Big Agnes, Scarpa, and Ortovox set up their brand-new products in the grass field for representatives to inspect. GVEALC, the nonprofit that bought the farm, is still hosting renters in both houses as of 2023, and the group plans to continue the vacation rentals.

In 2019, Moon Farm was placed on the official Mesa County Registry of Historic Landmarks. The 14-acre farm was acknowledged for its historic, social, and architectural significance. The designation included the property's 1935 resettlement farmhouse, chicken coop, garage, milking shed, treehouse, playhouse, log cabin, one-room schoolhouse, country store, and witch's castle, since they are the oldest buildings on the property and qualify for historic landmark status. Fruita's Historic Moon Farm has inspired the imaginations of children and adults for generations. From its humble beginning in 1954, when the Moon family bought the farm, until the present day, thousands of people have enjoyed many facets of this unique property.

One

True Pioneers

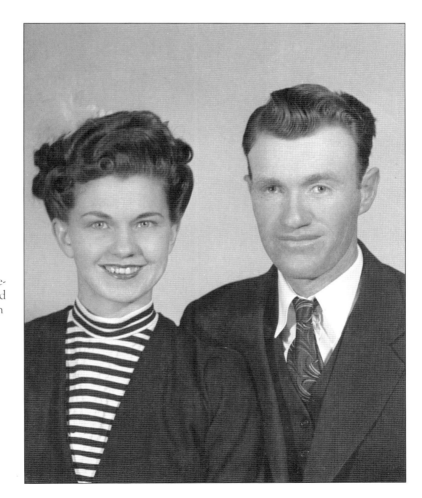

MOON FARM FOUNDERS, C. 1935. Wallace and Ella Moon, born in the early 1900s, were true pioneers. They traveled in covered wagons, lived in one-room log cabins, and utilized horse-drawn farm machinery. In 1954, the Moons bought an 80-acre farm in Fruita, Colorado. Their early experiences were re-created at this farm to teach children about pioneer life. (Courtesy of UCRHC.)

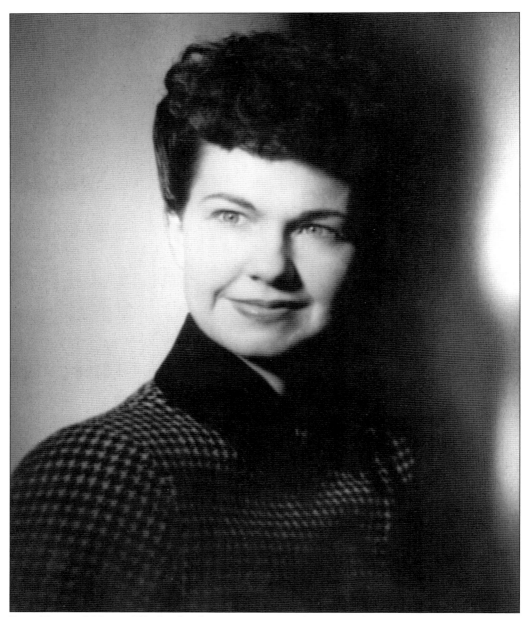

ELLA (CURFEW) MOON. Ella Curfew, born in Torrey, Utah, on March 14, 1918, was a strong-willed child who loved to be in charge. This carried over to adulthood. Never idle, Ella was a 4-H leader, youth director, dance teacher, seamstress, artist, and business-owner. She had a curious mind and was always learning something new. As a natural-born teacher, she loved sharing her skills and new knowledge with children and adults. Ella was a compassionate mother and a dear friend to many. The fall of 2012 and winter of 2013 were not easy for Ella. Her health was failing, but she was still positive and enjoyed telling stories to family members and friends. On February 17, 2013, Ella quietly passed away with her family by her side. She would have been 96 the following month. Many of Ella's family and friends passed on before her. However, at Ella's funeral, the church was standing room only because of her positive impact on so many in the Grand Valley.

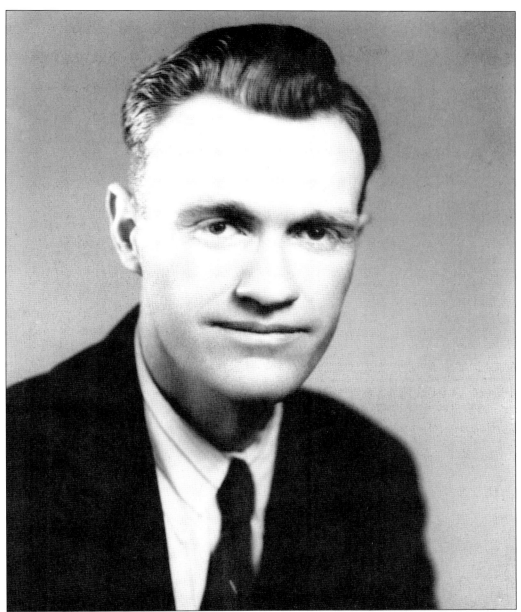

JOHN WALLACE MOON. Wallace Moon was not only known for creating Moon Farm; he was also a pillar of both communities where he lived (Jensen, Utah, and Fruita, Colorado). Wallace, born on September 29, 1912, in Jensen, Utah, had an easygoing demeanor and a love for children and horses. Growing up in a large family during the early 1900s was not easy. He lived through childhood diseases, the Great Depression, and two world wars. As a hardworking man, he was a farmer, cowboy, and carpenter. He was also a wonderful husband and a patient father, teaching his children life skills on the farm. Wallace shared his passion for horses with thousands of children in the community until 1994, when he was sidelined by a brain tumor. John Wallace Moon passed away at the age of 82 on March 28, 1995. Grand Junction's local newspaper, the *Daily Sentinel*, published an article about his passing with a picture of him, his team of horses, and his 1880s carriage.

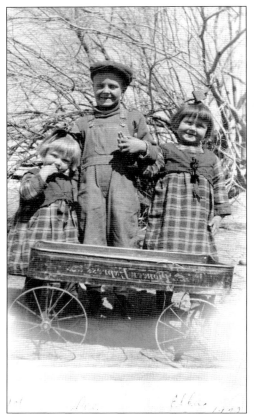

THE CURFEW FAMILY. Ella was the second of seven children born to Johny and Olive Curfew. When she was five years old, the family moved from Caineville, Utah, to Leota, Utah, in a covered wagon. The cold December trip took eight days. Ella and her siblings rode amongst their belongings in the wagon or walked alongside it. After settling in Leota, Ella's brother Dee helped his parents farm while Ella took care of her younger siblings—she was six years old and caring for a newborn, two-year-old, and four-year-old alone in their one-room log cabin. At the age of 10, Ella herded their cows in the nearby mountains. The children behind the wagon in the 1922 image at left are Iola (left), Dee (center), and Ella Curfew. Below is the Curfew family. From left to right are (first row) Iola, Johny, Olive, and Gean; (second row) Ed, Ora, Jay, Ella, and Dee. (Below, courtesy of UCRHC.)

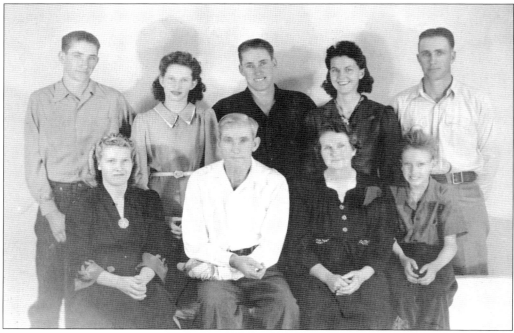

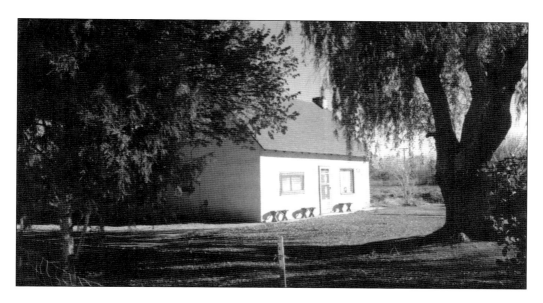

TOUGH TIMES IN CAINEVILLE. When Ella was two years old, the Curfew family lived below Caineville, Utah, on Ella's grandma Eliza Curfew's lower ranch. It was five miles to Caineville, where Eliza Curfew lived, and she owned the only store in Caineville. Ella and her siblings often rode in their wagon to their grandma's store for groceries. During the two years the Curfew family lived on the old homestead, there were many floods. The family finally got a crop to grow, and another surge came, forcing them to plant again. The last straw was the flood of 1921, and the Curfews decided to move to the upper ranch with Eliza. They lived with her for a year before their journey in a covered wagon to Leota, Utah. Eliza Curfew's remodeled house is pictured above. Below is the school/church the Curfews attended in Caineville.

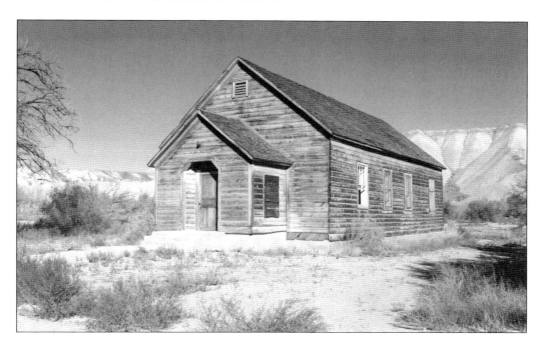

HOME IN LEOTA. Ella (front left) is pictured standing by the Curfew home in Leota. Her family of seven resided in this one-room log cabin. Ella and Wallace re-created a smaller version of the log cabin at Moon Farm. They even built a rock fireplace and wood furniture. Ella taught children about pioneers in the log cabin at the farm. (Courtesy of UCRHC.)

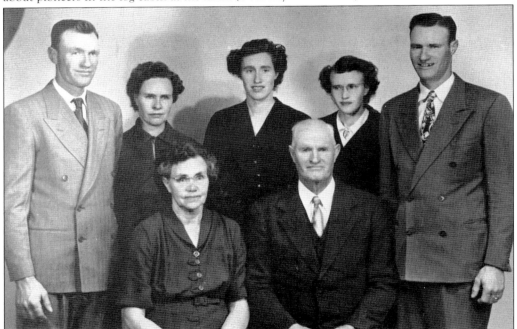

THE MOON FAMILY. Wallace was the second of six children born to Moroni and Maggie Bell Moon. The youngest, Donald, died of pneumonia at the age of six. Pictured are, from left to right, (first row) Maggie Bell and Moroni; (second row) Wallace, Vera, Velma, Edith, and Ferron. Wallace was raised in Jensen, Utah, and helped his dad with farming, ranching, and road building. (Courtesy of UCRHC.)

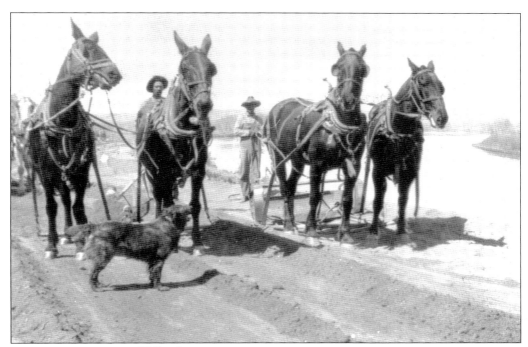

FARMING WITH HORSES. Wallace's dad, Moroni Moon (right), is pictured with his team of horses and Fresno Scraper. Moroni and Wallace built roads. They also farmed using horses and horse-drawn farm machinery in Jensen, Utah. Wallace even farmed 80 acres at Moon Farm with his horse-drawn implements. He did this for two years before buying his first tractor.

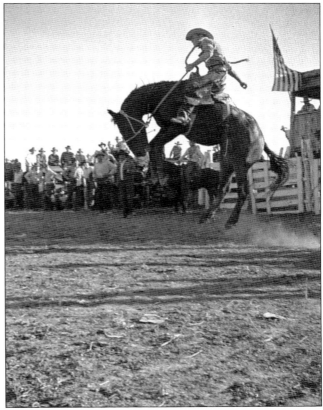

HORSES AND RODEOS. Wallace Moon loved horses. In his free time, he made his own bridles and ropes. His braiding skills were the best around. He also enjoyed rodeos. He and his friends entered competitions in the area. Pictured is a bronc rider in the 1939 Vernal rodeo. Wallace and other soldiers even put on a rodeo in Japan after World War II ended. (Courtesy of UCRHC.)

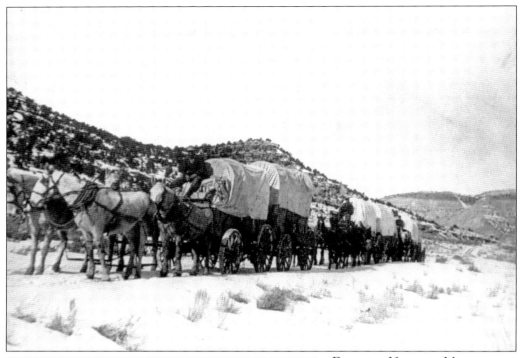

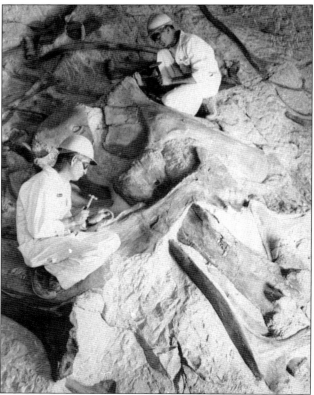

DINOSAUR NATIONAL MONUMENT. Wallace Moon's dad, Moroni, worked at Dinosaur National Monument with renowned paleontologist Earl Douglass. In the early 1900s, Moroni helped haul the first fossils excavated from this site to the Uintah Railway with his horse-and-wagon team. Pictured above are wagons hauling dinosaur bones. The apatosaurus bones were transported to the Carnegie Museum in Pittsburgh, Pennsylvania. They shipped thousands of fossils back east from the years 1909 to 1915. About 40 years later, Wallace worked at Dinosaur National Monument uncovering the fossils that are now on the wall. He did this for a brief period around 1953 before Tobe Wilkins and Jim Adams, who were fossil preparators at Dinosaur National Monument for more than 20 years; Wilkins (right) and Adams are shown in the picture at left. (Both, courtesy of UCRHC.)

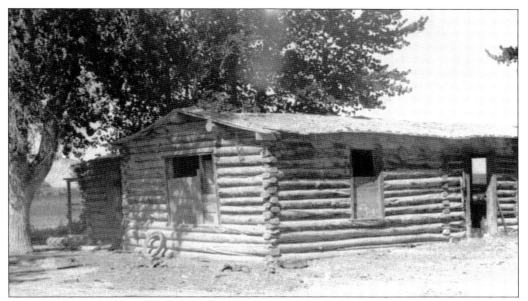

CURFEW HOME, C. 1933. At 15, Ella Curfew's family of nine moved from a one-room log cabin in Leota, Utah, to this log house built by Ella's dad, Johny. It was located on the Sunshine Ranch in Jensen, Utah. This ranch was owned by a banker named N.J. Meagher. Johny was the manager of the ranch along with leasing 300 acres to farm for himself.

ELLA'S HIGH SCHOOL PLAY, 1935. Ella Curfew loved drama classes at Uintah High School. Here, Ella (second from left) is performing in *Peg of My Heart*. She played Ethel, Mrs. Chichester's daughter. Ella's love of acting transferred over to the Moon Farm day camp, where the children performed plays for fellow campers. (Courtesy of UCRHC.)

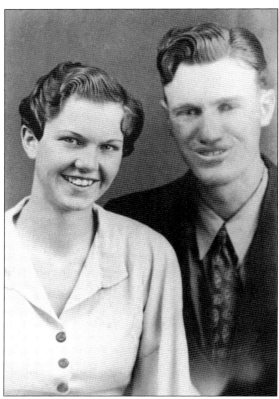

WALLACE AND ELLA'S WEDDING. Wallace Moon and Ella Curfew wed on June 2, 1936. Wallace was 24, and Ella was 18. The couple lived in Jensen, Utah, until 1954, when they adopted three children. In 1954, the family moved to Fruita, Colorado, and Wallace and Ella adopted four more children. Wallace liked to tell his friends that he raised several teenagers—the first happened to be Ella. (Courtesy of UCRHC.)

FARMHOUSE IN JENSEN. Wallace built this farmhouse north of his parent's house in Jensen, Utah. Farming was not an easy livelihood during the 1940s due to severe drought in the West. Fighting over water was a regular occurrence. Wallace recalled farmers hitting each other with shovels at the headgate while trying to divert water to their fields.

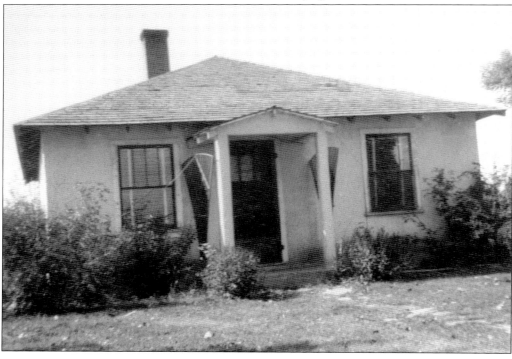

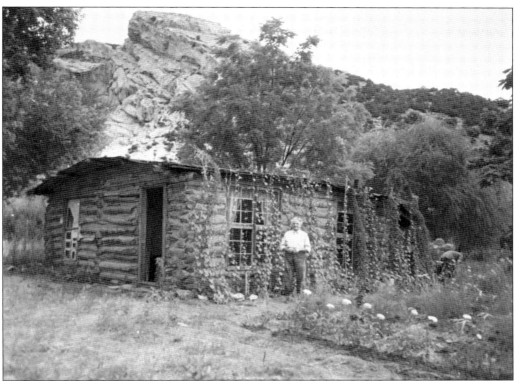

CUB CREEK ADVENTURES. When Wallace Moon came down Blue Mountain after herding cows, he would often stop by Josie Bassett Morris's cabin (pictured above) in Jensen, Utah. At the age of 39, Josie established a homestead on Cub Creek. Her log cabin is now listed in the National Register of Historic Places. Wallace remembered her as a pioneer, rancher, and good host. However, Ella recalled a few more details. Josie and her sister Ann had been associated with the outlaw Butch Cassidy. She was also a bootlegger and was tried and acquitted twice for cattle rustling; Ella attended one of her trials. Josie was married five times, and it was rumored that she poisoned one of her husbands. Pictured at right are Ella (right) and her sister-in-law Edith. They would often ride horses at Cub Creek. (Above, courtesy of UCRHC.)

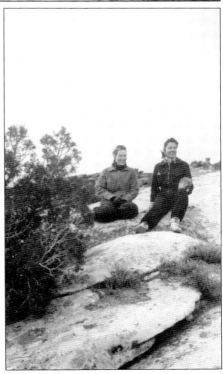

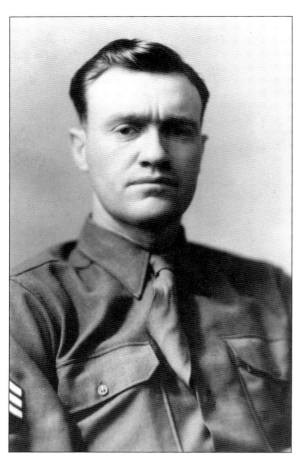

WALLACE IN THE ARMY. This is a picture of Wallace Moon during World War II. He was inducted on May 2, 1945, at Fort Douglas, Utah, and trained in Texas. His rank was technician fourth grade with an occupational specialty of carpenter. His carpentry skills were utilized on an airbase in Japan until his departure on November 2, 1945.

MINERAL WELLS POSTCARD, C. 1940. During World War II, Wallace trained at Camp Wolters, Texas. Ella traveled to Mineral Wells, four miles northeast of Camp Wolters, and ran the cash register in the Army's post exchange. When Wallace was in Japan, Ella worked at an ice-cream shop with her sister Ora in Salt Lake City before going home to Jensen. This was Ella's postcard from Mineral Wells.

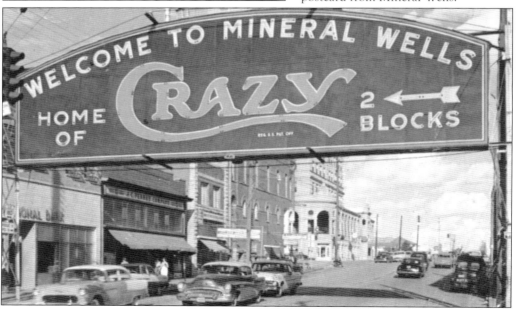

ELLA MOON'S SEWING SKILLS. Ella had a photographer take this picture of her wearing an outfit she sewed. She then mailed the picture to Wallace in Japan during the war. Ella made all of her own clothes—as well as dresses for her daughter Mary Joan—in the early days. As a skilled seamstress, she also sewed thousands of costumes for her dance shows in Jensen, Utah, and Fruita, Colorado.

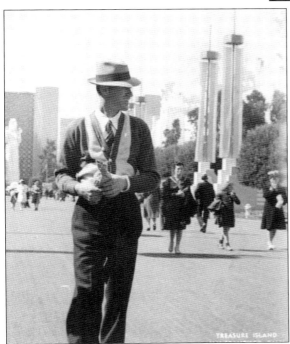

WORLD'S FAIR, SAN FRANCISCO, CALIFORNIA. Wallace Moon is pictured at the 1940 World's Fair. The 81-foot *Pacifica* statue towered over the entrance; the statue is visible in the background at far left. Wallace and Ella attended the fair with another couple. Both couples were persuaded to buy property in California. However, when they returned home, their parents had other ideas, and they were convinced to sell their land.

St. James Church. Wallace Moon helped build the interior of St. James Catholic Church in Vernal, Utah. This picture shows the craftsmanship of Wallace and the other carpenters. It was a challenge to finance the building, since there were not many parishioners at the time. However, the church grew as people relocated because of oil business in the area. St. James Catholic Church is still active today. (Courtesy of UCRHC.)

Wallace Reminiscing at Blue Mountain. Wallace Moon led Boy Scout troops in Jensen, Utah. It was not unusual for the scouts to have overnight trips around the Blue Mountain area on horseback. Since they did not have trailers to haul their horses, they started out in Jensen and rode on from there. One excursion was from Jensen to Mapledell Park in Payson. Another trip was a trek over the Outlaw Trail.

Two

THE EARLY DAYS

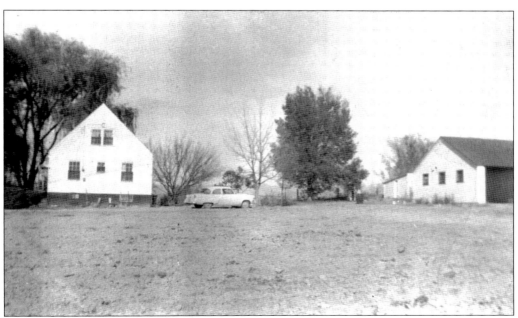

MOON FARM, 1954. The Moon family moved to Fruita, Colorado, in 1954. Bray and Company Realty sold Wallace and Ella a 1935 Grand Valley Resettlement Farm. The government built this farmhouse on the western slope of Colorado during Franklin D. Roosevelt's New Deal program. In addition to the farmhouse, each farmer was given a chicken coop, milking shed, small A-frame brooder house, and cistern. In 1954, the original buildings were all still intact.

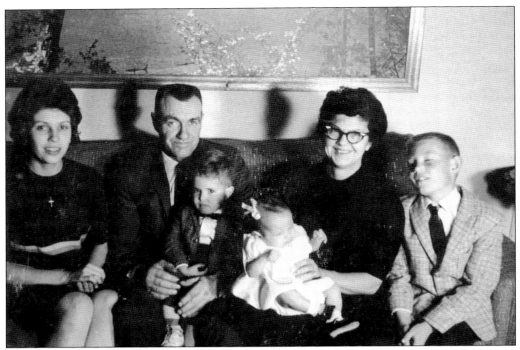

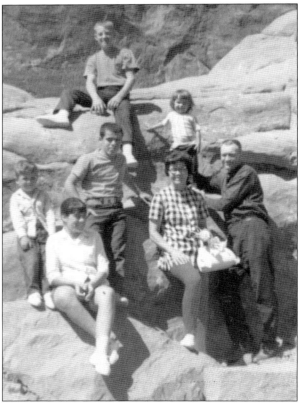

WALLACE AND ELLA MOON FAMILY. Wallace and Ella adopted seven children. Four were adopted as babies: Mary Joan, Mike, David, and DiAnn. Three were adopted at the age of 11: Earl and twins Nick and Anna. The Moons were not planning on more children after DiAnn, but Catholic Charities talked to them about twins in an Italian orphanage, and when the Moons came into a little extra money, Ella said it was a sign to bring Nick and Anna over, completing the Moon family. Earl was grown and in the military when these pictures were taken. Above is a family photograph taken in 1962. From left to right are Mary Joan, Wallace, two-year-old David (on Wallace's lap), Ella, baby DiAnn (on Ella's lap), and Mike. The family members in the c. 1966 photograph at left are, from left to right, (front row, seated) Anna, Ella, and Wallace; (second row, standing) six-year-old David, Nick, and four-year-old DiAnn; Mike is sitting on the rocks above Nick.

YOUNG EARL MOON. This picture shows Earl Moon as a young boy. He was adopted in 1950 at the age of 11 while the Moons were living in Utah. Earl was 15 years old when the family moved to Fruita in 1954, Colorado. He helped his dad on the farm for a few years before joining the Marine Corps and moving away from Fruita. (Courtesy of UCRHC.)

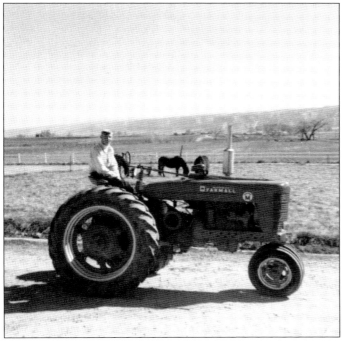

MOON FARM'S FIRST TRACTOR. Since the Moons lived on a farm in Jensen, they also planned to farm in Fruita. Wallace brought his team of horses and farm implements from Jensen. He used them to farm his crops of corn, hay, and oats. In 1957, Wallace was able to buy his first tractor, a Farmall M. Mike Moon is pictured on the Farmall helping his dad.

WALLACE BUILDS AN ADDITION. When the Moons bought the Fruita property in 1954, the resettlement farm looked the same as when it was built in 1935. It consisted of the original farmhouse, a milking shed/garage, a chicken coop, and a barnyard with an A-frame brooder. However, in 1958, Wallace built a large addition to the farmhouse that nearly doubled the area of the main floor and upstairs. A large family room was added downstairs with a flagstone fireplace. The upstairs expansion included a wide hallway and back bedroom. The bedroom later became Ella's sewing room. The farmhouse is pictured in the late 1960s. The milking shed became Wallace's workshop; an addition was built, and the garage was moved to the east end. A doll room, Mini Museum, and restrooms were also added to that original building. Wallace's workshop and the garage now house a Barbie collection. The chicken coop was transformed into Granny's House and is now called Great Granny's House.

MIKE WITH TOBY. Mike Moon enjoyed his freedom at Moon Farm in the early days, so Wallace and Ella bought a dog to keep him company. Ella loved being able to keep track of Mike and had to use Toby. Whenever she called Mike's name, he would not answer, but Toby barked, revealing Mike's secret location. For quite some time, if Toby passed away, Ella replaced him with another "Toby."

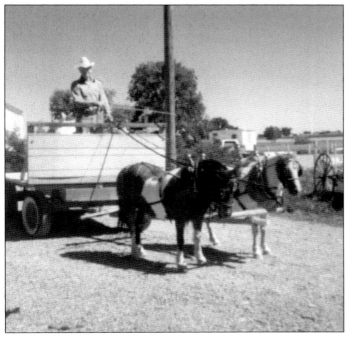

WALLACE TRAINING PONIES. Wallace is shown training two ponies using a wagon. The Moons owned many horse-drawn vehicles, and Wallace enjoyed breaking horses to drive. He mainly worked his quarter horses. He used one horse with the doctor buggies, while the surrey with the fringe on top, covered wagon, and carriage were driven with two horses. It was difficult to drive the stagecoach with four horses, but Wallace loved the challenge.

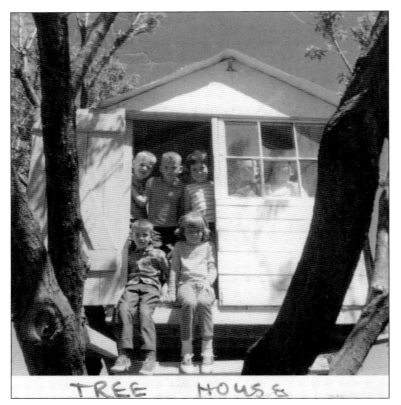

MOON FARM'S TREEHOUSE. The *Swiss Family Robinson*–inspired treehouse was built in 1959. Ella enlisted Mike to help her with the construction. Ella recalled eight-year-old Mike hoisting the floor of the treehouse into the air with a pulley system. Mike said they started on the treehouse while Wallace was at work, with his dad later helping to build the walls and roof.

THE TREEHOUSE TRADITION. The first treehouse had boards nailed to the tree to be used as a ladder—the steps were added later. It was painted white, then blue, and finally striped red and white. The treehouse has been reinforced and repainted several times throughout the years. However, the apricot tree, original floor, and wood were always left intact. It is hard to estimate how many children have played in the treehouse over the years. It has always been a favorite at Moon Farm.

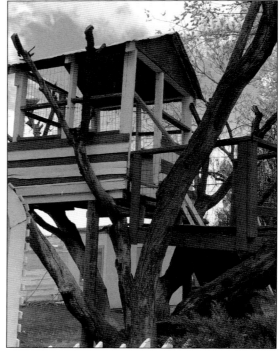

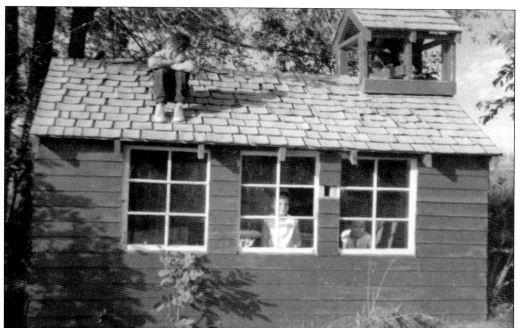

SCHOOLHOUSE AND WISHING WELL. Ella and Mike built the schoolhouse in 1960. The floor came from an old shed found on the Moon property, and the wood was seconds bought in Fruita. Ella was resourceful and found old desks, a slate chalkboard, and a bell. All original furniture was kept in place, but the inside was redecorated around 2010. The above picture shows David sitting on top of the schoolhouse. Karen Barslund (left) and DiAnn are inside. A few years after the schoolhouse was built, Ella decided there should be a wishing well for the children, and Wallace built it east of the schoolhouse. He used a 55-gallon metal drum and mortared brick around it. He made an A-frame roof and shingled it. A bucket was even attached to a rope with a pulley system. The wishing well was in place until the mid-1980s.

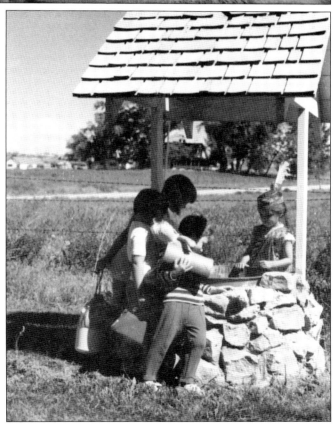

DiAnn's Playhouse, 1962. The playhouse was built in 1962 for DiAnn's first birthday. It was white with red trim and a small front porch. The original table had two chairs and was later placed behind glass in the doll room. Sometime between 1969 and 1979, Wallace built a bed, table, and bench. Ella painted them with flowers and sewed curtains for the windows.

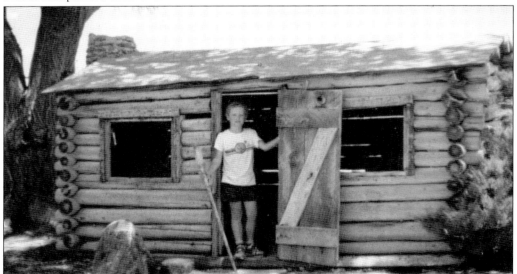

One-Room Log Cabin. The log cabin was built around 1967. Even though David was only seven, he remembers pounding spikes into the logs and stacking rocks for the fireplace. The furniture was handcrafted by Wallace. Ella made the quilt bedspread and rag rug. The log cabin was also used as a playhouse during the years that the day camp was in existence—children could pretend they were pioneers living in a one-room log cabin.

ELLA MOON'S DANCERS. Ella was a dance teacher and always owned her studios. In the 1940s and 1950s, she taught tap dance in Jensen, Utah. Ella choreographed the dances, instructed the children, sewed the costumes, constructed the scenery (with the help of Wallace), and held recitals in the Jensen Ward Hall. She continued the tradition in Fruita, teaching tap and ballet. The basement was used as her studio on the farm. Some mothers waited upstairs for their daughters. Ella made them cookies and coffee while they visited in the living room. However, she put everyone to work when it was time for a recital. Sometimes, she would even ask mothers to participate in lessons and join the dance recital. Ella loved to be involved in the community and entered her dancers in Fruita parades.

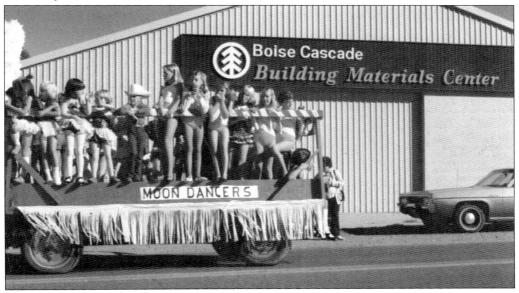

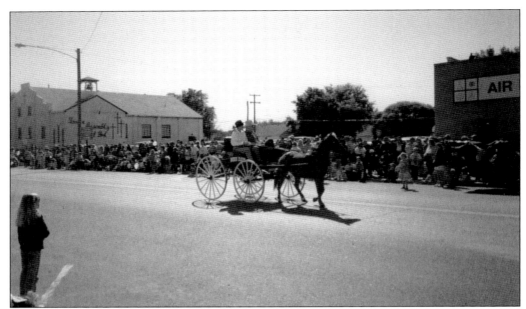

PARADES THROUGH THE YEARS. The Moons entered many parades over the years. Early entries were floats with Ella's dancers on board. Wallace even built a schoolhouse on his flatbed for a back-to-school parade during the 1960s—it won first place for the float division and was featured in the newspaper. After the parade, the schoolhouse was transformed into the Little Brown Church in the Wild Wood and placed in the Moons' backyard. Wallace also hitched his horses to the covered wagon, buggy (pictured above), carriage, or stagecoach to give children rides through the parade routes. After the Moons purchased a train, it was named the Moon Farm Express, and entered parades (pictured below). Stanley the Stegosaurus even became part of the parades, as the Fruita Chamber of Commerce borrowed Stanley for one event.

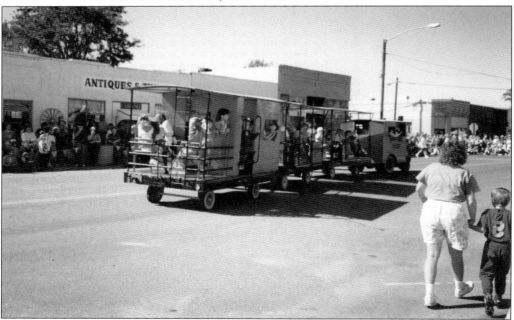

MOON FARM BACKYARD, C. 1967. Ella and David built the first dinosaur at Moon Farm in 1965. A sawhorse was used for the body, and pipes were the neck and tail. It was covered in chicken wire and burlap coated with cement. The first tepee was made using poles from the barnyard and canvas with painted-on symbols. The totem pole was carved, painted, and then placed near the tepee.

DAVID (LEFT), CISCO, CURTIS, AND WALLACE. The Moons usually owned a donkey for visitors to pet and day campers to enjoy. The donkey in this picture is Cisco, but Bullet, a day-camp favorite, could still be seen at Moon Farm until August 2022, when he died of old age. Curtis the llama had a pen near the parking lot, and he greeted thousands of people. After Curtis passed away, Wallace bought another llama named Boomer.

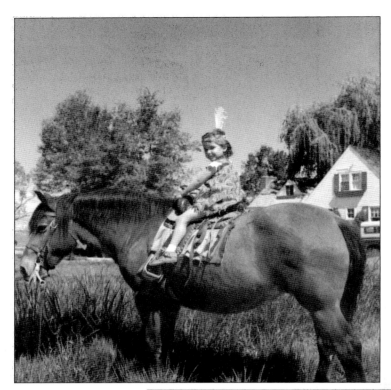

SCHOOL FIELD TRIPS. Moon Farm field trips started in 1965, when David Moon was in kindergarten and invited his class out to see the family farm. At that time, there was one horse to ride—Ole Joe, pictured here with DiAnn—and the barnyard, treehouse, schoolhouse, and playhouse. Each year, more classes came to the farm for field trips. Teachers have been bringing their students to Moon Farm for 57 years.

MOON FARM RIDE, C. 1974. Many children have experienced different types of rides at Moon Farm. Pictured is an example with a cart and donkey. There were also several ponies and horses around the farm in the early days. Wallace loved hitching his horses to the hay wagon, covered wagon, and stagecoach. The spaceship, carousel, and train also offered fun rides to experience at Moon Farm.

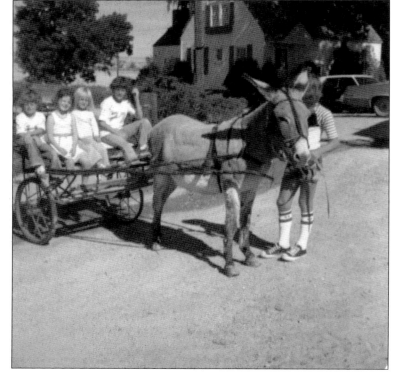

RIDING THE PONIES. Moon Farm offered pony rides on a pony wheel (or carousel) for visitors and younger day campers until it was retired in 2012. Six ponies could be hooked to the carousel for large events. However, on most days, there were two to three alternating ponies. The carousel and ponies were taken to Fruita festivals and Grand Junction events. Amy Meyer is shown riding Bandit. (Courtesy of Becky Karisny.)

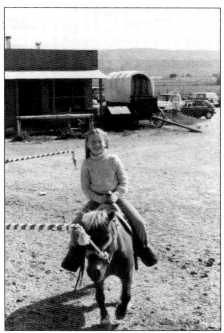

BARNYARD PETTING ZOO. There has always been a petting zoo in the barnyard. Children enjoyed petting the bunnies, goats, sheep, pigs, calves, and ponies over the years. Pictured below is the area where the calf and goats were kept. Ella Moon also loved birds and had quite a collection of pheasants at one time. Visitors liked looking at geese and ducks in the pond. Chickens and peacocks always roamed around the farm.

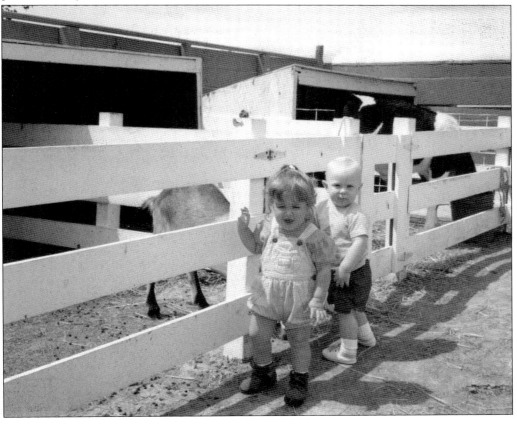

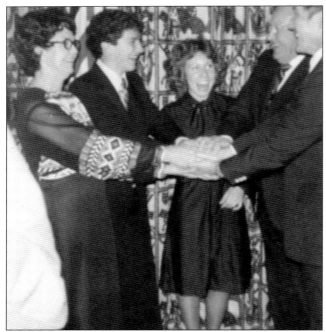

ELLA MOON'S AWARDS. Ella (left) is pictured along with other unidentified recipients of the 1977 Grand Junction outstanding citizens award. They are shaking hands with astronaut Jack Swigert. In 1984, Big Sisters of Colorado honored Ella during their Salute to Women. The Fruita Chamber of Commerce also presented her with an outstanding citizen award in 1987. She earned other accolades for her work with children and adolescents over the years.

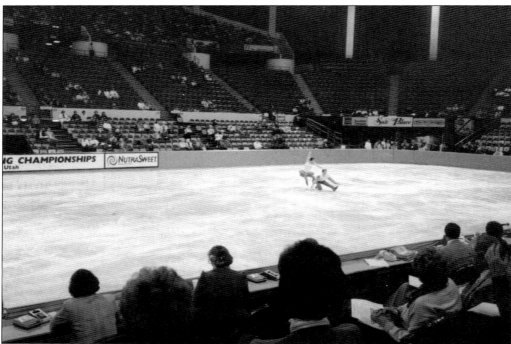

FIGURE SKATING CHAMPIONSHIPS, 1990. Ella Moon's niece Talitha Day asked her to join the seamstress team during the 1990 US Figure Skating Championships at Salt Lake City's Salt Palace. One skater (pictured with her partner) had a dress with too many layers, and she was almost disqualified. Out of all the seamstresses there, Ella was the only one who could rip apart the costume and sew it back together in time for the competition.

Three
DREAMING AND BUILDING

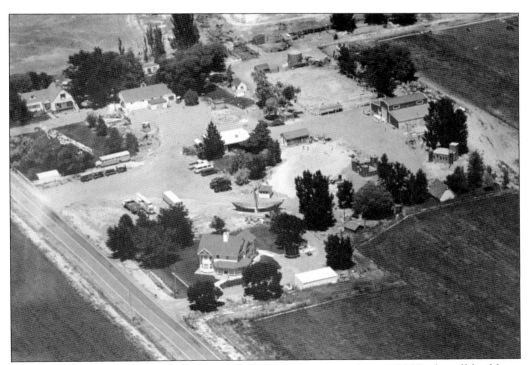

AERIAL VIEW OF MOON FARM. This picture of Moon Farm was taken in 2008 after all buildings were in place. The history behind these playhouses and museums began with field trips coming to the farm every spring starting in 1965. Ella wanted a new building each year for the schoolchildren to enjoy. She formed an idea in her head and told Wallace, and he built it. They were the ultimate dreamers and builders.

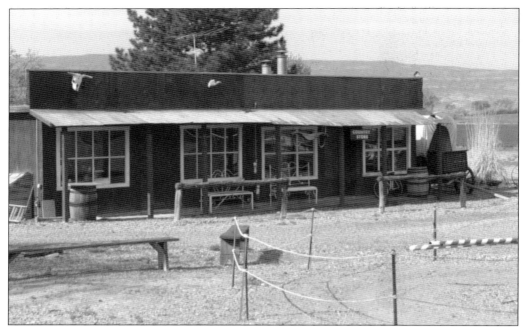

COUNTRY STORE AND SALOON. The country store and saloon were built in the early 1970s. After Wallace constructed the country store, Ella displayed an antique cash register, a coffee mill, the original Fruita post office, and many Native American articles. An old soda fountain from Colbran, Colorado, is exhibited in the saloon along with barstools made by Wallace and a piano for children to play.

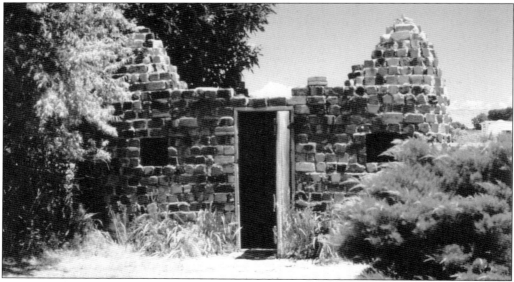

THE WITCH'S CASTLE. Wallace built the Witch's Castle in 1969. The bricks used were discarded from the coke ovens at Fruita's Gilsonite Refinery, where he worked. The brick coke ovens were used to convert mined coal into industrial coke. Ella dressed a mannequin as a witch, sewed some stuffed black cats, and found a cauldron to place in front of the witch. Day campers loved to play inside and built forts on top.

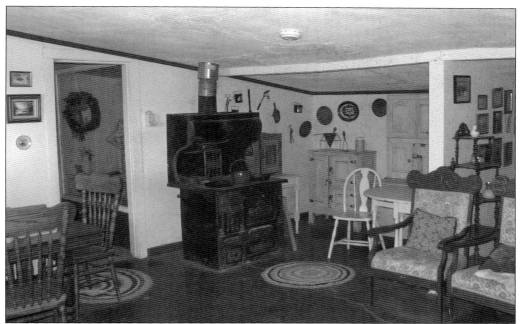

(GREAT) GRANNY'S HOUSE, C. 1966. Granny's House was a chicken coop built in 1937. Around 1966, the Moons transformed it into an early-1900s playhouse. They found a pump organ, a wood cookstove, an icebox, a cupboard, a table, and a bed to display. Many other items were added later to enhance this pioneer home. Ella called it Granny's. As time went by, she decided it would no longer be a granny's house, but rather a great-granny's house. Consequently, the name changed. Two walls were wallpapered using thank-you notes written by children who came to the farm on school field trips, as shown in the below image. The brides' room was added around 1973. There were three generations of bride mannequins on one side and a bridal party on the other. The brides' room was changed into an antique collection in 2016.

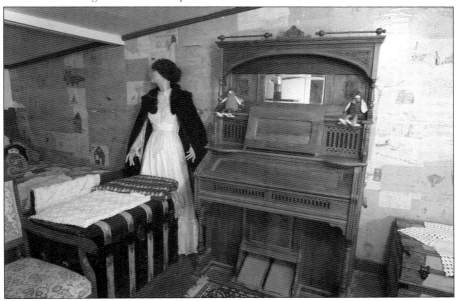

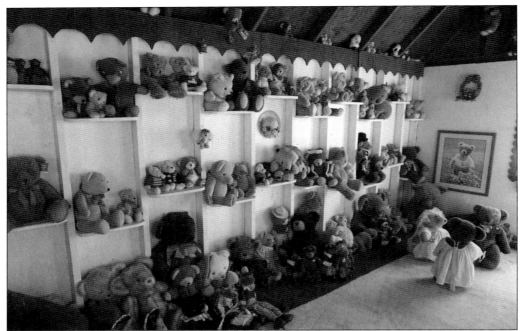

TEDDY BEAR HOUSE. The Teddy Bear House was featured in a *Daily Sentinel* newspaper article in 1982. According to the article, Ella started her collection of bears when a friend gave her a secondhand, scruffy-looking fellow that she opened her heart to. She named him Buddy Bear because he was someone's buddy. Ella also created a bear wedding complete with a bear bride, groom, and preacher. On the far wall, Wallace built shelves where Ella displayed teddy bears. During Ella's teddy-bear phase, her daughter Mary Joan found a bear pattern in a magazine. That was all it took for Ella's production of homemade teddy bears to begin. She sewed numerous bears. Even though she did sell some in the Country Store at Moon Farm, most were given away to family, friends, and—of course—children.

THE ITALIAN HOUSE. Ella wanted Wallace to build an Italian House at Moon Farm because their friends Roland and Rae Marasco were from Italy. It was built in 1984 and named Casa Marasco. Rae Marasco is pictured standing by Casa Marasco in 2019. One wall is papered with Italian magazine pictures from Rae, and it contains many other Italian-inspired items. (Courtesy of Bernie and Ruth Marasco.)

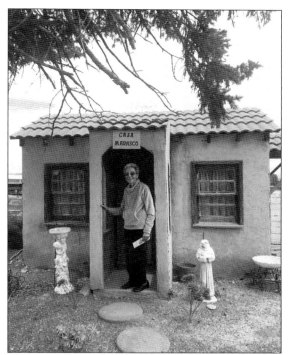

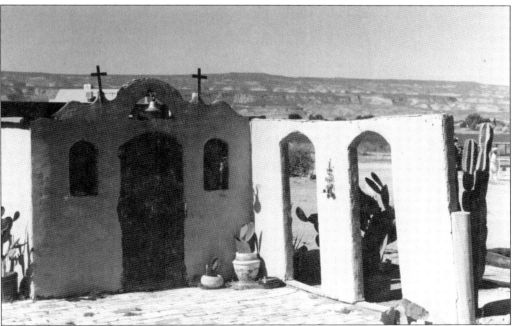

THE MEXICO HOUSE. The Mexico House was built in 1972. Ella called it the Alamo. Several items had been brought back from Mexico. Others were donated or found at antique stores and yard sales. Notice the cactus plants in this picture taken during the summer. They had to be stored inside during the winter months. Since the enormous cactuses became too heavy to haul, they were eventually replaced with yucca plants.

FAR EAST AREA. The Far East area consists of two buildings on the west side of Great Granny's House that were built in the early 1970s. Pictured are the first building and a shrine where the second playhouse would be built. When Wallace was in World War II, he brought back some artifacts and three flags from Japan. Ella found pictures and other items from the Far East at yard sales.

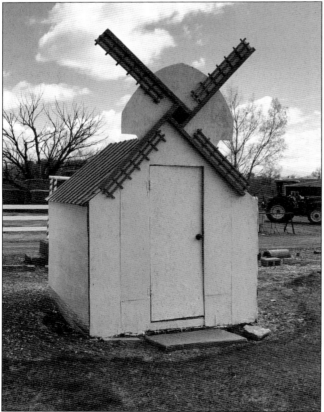

THE DUTCH HOUSE. Wallace retired from working at Gilsonite in 1974 and built Ella a small Dutch House complete with a windmill. She placed a collection of wooden shoes on the floor for children to wear. Wallace also built two shadow boxes and several little showcases that Ella filled with Dutch knickknacks. Ella made the blue-and-white rag rug, tablecloth, and chair covers.

MOON FARM CHURCH. The first little church at Moon Farm was built in 1966. David remembers it being called the Little Brown Church in the Wild Wood. It was created for a Fruita parade and then set in the Moon's backyard. The Little Brown Church was replaced in 1992 by the current church (pictured at right), which was built by Wallace and David. Ella painted the ceiling blue with clouds and cherubs. She also painted a picture of Jesus surrounded by children in front of the organ and framed it (as shown below). Electricity was installed so children could play the organ. The four kid-sized pews were built by Wallace, and the stained-glass windows were created by Ella and David.

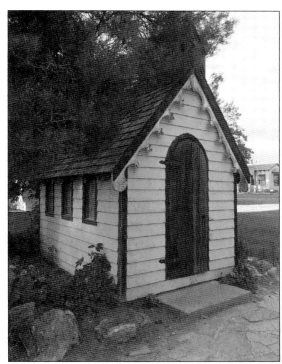

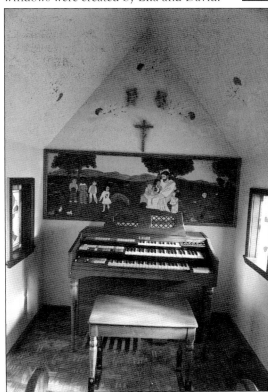

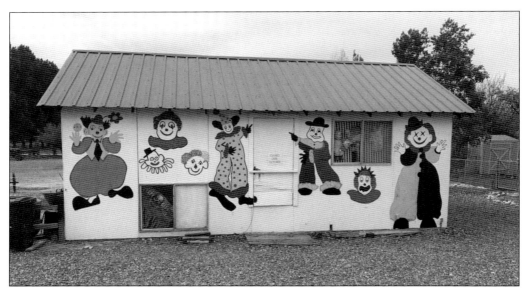

THE CLOWN HOUSE. The clown house was built around 1975 as a dance studio. It has been used for dance classes, a day-camp pool room, and, more recently, a haunted house for the pumpkin patch. Since a family friend was a jokester, Ella had an idea to convert the dance studio into a house full of clowns and dedicate it to him. It was then called the Bill Bush Clown House. Ella collected clowns and even made her own from scratch. She sewed circus material, batting, clown faces, hands, and feet to create unique, homemade clowns. She even bought several ceramic clowns from Pat's Shop in Fruita to display. All of the clowns were still in the "Creepy Clown House" as part of the 2022 pumpkin patch.

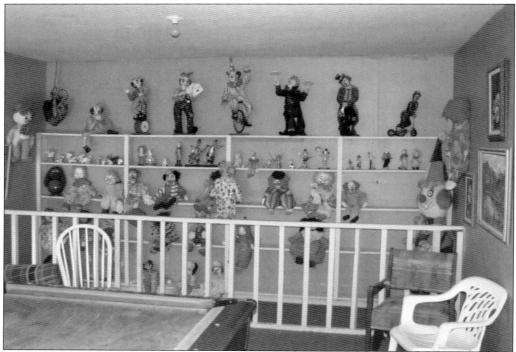

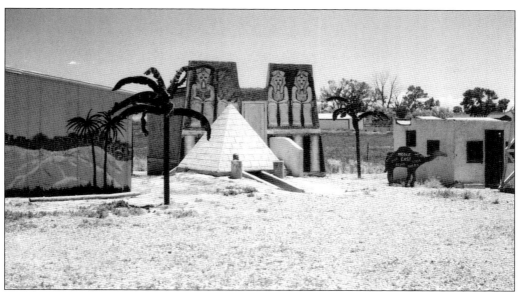

THE MIDDLE EAST AREA. Ella's brothers worked in the oil fields in Iran during the 1970s. Their description of the buildings and culture inspired Ella to construct the Middle East area. This area included a house, pyramid, oil well, and Egyptian temple. Ed and Maxine Curfew, as well as Jay and Fran Curfew, brought back artifacts from Tehran and Ahwaz. The Garlitz family, friends of the Moons, also traveled to the Middle East and donated items to the Moons. The Middle East House was built around 1977, and a year later, the day campers helped build the pyramid. The pyramid housed a tomb complete with Anubis (the jackal) guarding the pharaoh. Ella painted designs on the ceiling. The oil well was added in 1986; unfortunately, it blew down several years ago and was removed.

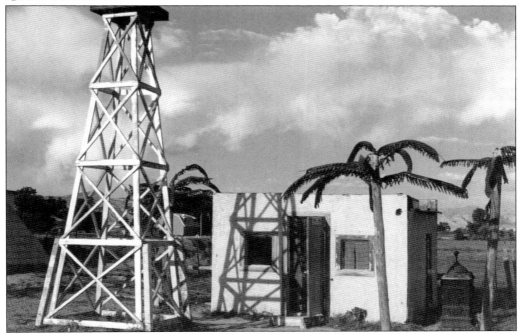

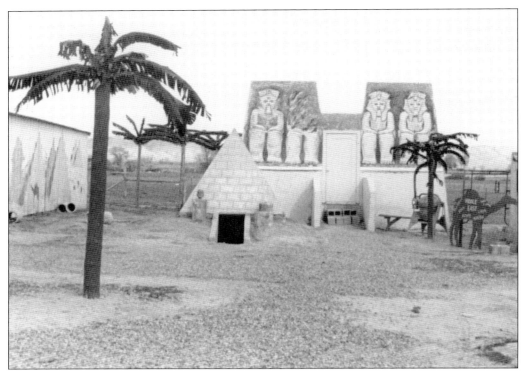

THE EGYPTIAN TEMPLE. In 1986, Ella asked Wallace and David to build a King Ramses II temple at Moon Farm. She handed them her book with the picture of his temple at Abu Simbel. They constructed the building and painted the outside. It depicted four seated statues of Ramses II (shown above). Ella painted each wall by looking at pictures in her book. The below image shows Ella's painting of Egyptian dependence on agriculture. Ella also painted scenes on canvas that she framed and hung. Many items inside the temple were brought back from the 1987–88 King Ramses II traveling exhibit that stopped in Denver. Ella dressed a mannequin as King Ramses II's favorite wife, Nefatari, and placed it in the showcase. However, before she dressed the mannequin, Ella wore the homemade costume she created to teach her friends about Egypt.

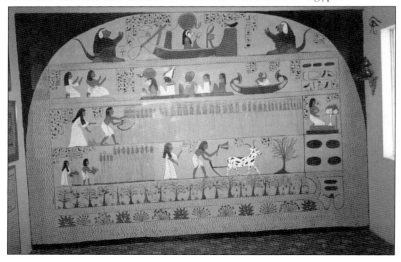

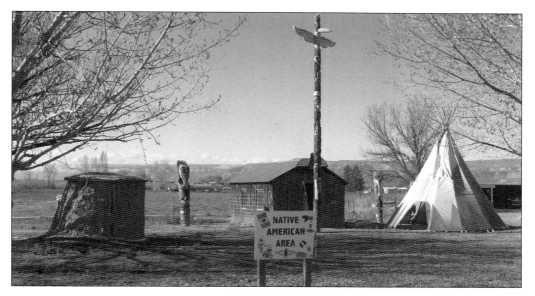

Native American Area. The Native American area has been in three different locations at Moon Farm. The first location, which was home to the area from approximately 1967 to 1970, was east of Great Granny's House, where the Italian House now sits. It was then relocated south of the clown house from around 1979 to 1993. A museum was added with mannequins dressed to represent different tribes. The current Native American location—complete with a longhouse, tepee, and mud hogan—is pictured above. This area taught children that each Native American community had different customs. David complemented the old totem pole with a new, hand-carved 25-foot pole featuring an eagle, a beaver, a frog, and a brown bear. Below, David is shown carving the newer totem pole.

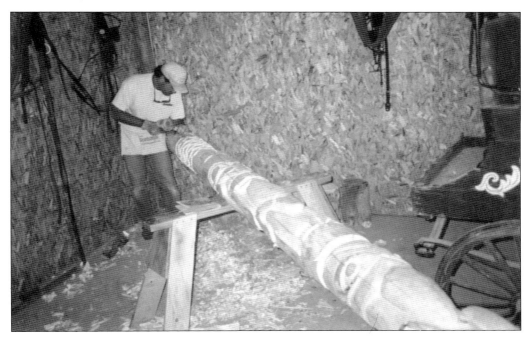

THE TLINGIT HOUSE. Around 1994, when the Native American area was moved to its third (and current) location, the former museum was transformed into a Tlingit Clan House. Ella painted a design on the back wall and also dressed the mannequin with her handsewn replicas of a tunic, Chilkat blanket, and hat. Ella made extra Chilkat blankets to hang on the wall and use for International Days at day camp. There were even sealskin moccasins in the showcase. Wooden masks were displayed on the opposite wall. Since Ella read about raven tales being the traditional human and animal creation stories of the Indigenous peoples of the Pacific Northwest, she wanted ravens on the outside of the house. She found a raven pattern, which Wallace cut out of wood, and day campers helped Ella paint the birds.

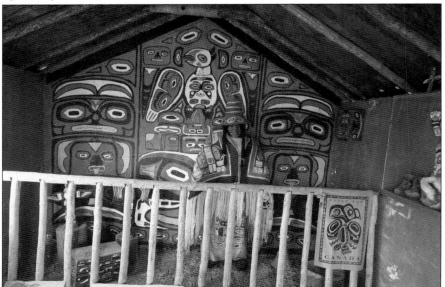

THE PLAINS TEPEE. Since the old tepee needed to be replaced in the late 1990s, David ordered a new canvas tepee and painted a design on the bottom, as shown in the image at right. Everything in the below picture was handcrafted by Wallace, Ella, and David, even the cradleboard and drum. Ella painted symbols on the drum. Since she was an expert seamstress, she sewed leather pants to fit the mannequin. The leather shirt with beads was also homemade. Ella created the headdress using feathers and beadwork. There were many headdresses and Native American costumes in the basement for day campers to wear. They would dress up for cultural programs, International Day, fashion shows, skits, dance programs, and other activities.

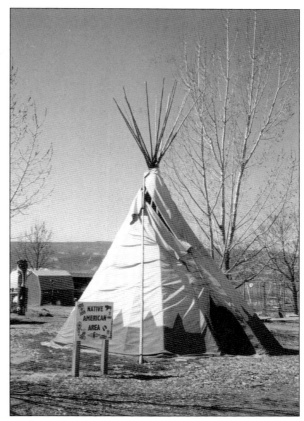

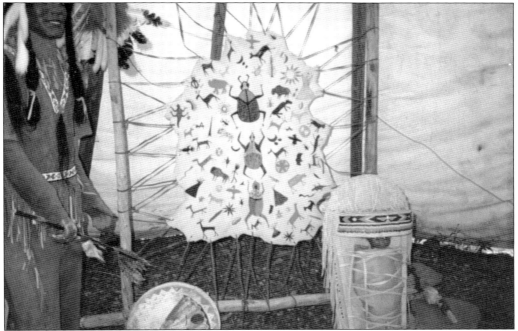

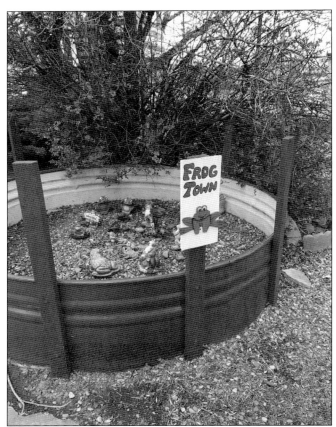

FROG TOWN TANK. Pictured is the old metal tank the Moon kids used as a swimming pool in the 1960s. It was converted to a tank for frogs and lizards when the day camp started. After day camp was retired, Ella placed ceramic frogs in the tank and named it Frog Town. The tank and ceramic frogs were repainted by Mary Joan around 2017.

THE AFRICAN JUNGLE. The jungle was built in 1998 on the north side of the farmhouse. David painted a jungle scene on the house. Palm trees were made from wooden poles and sewn leaves. Many large stuffed animals were purchased and placed around the jungle. Day-camp junior counselors helped Ella make a grass hut. During October, the old animals were used in haunted areas.

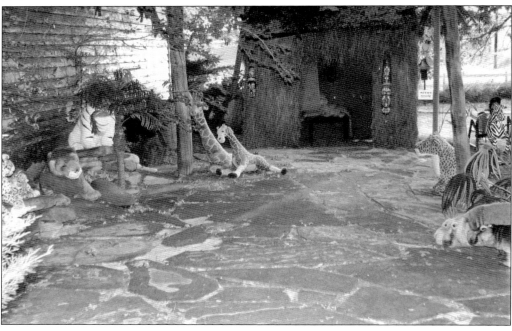

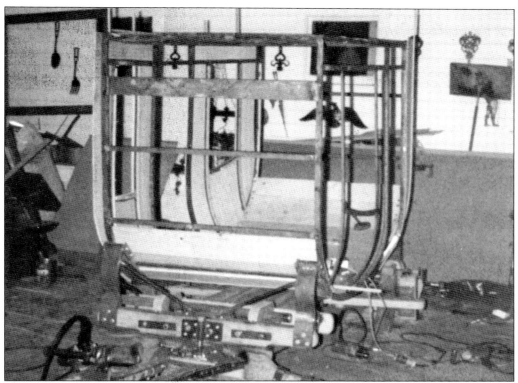

THE CONCORD STAGECOACH. The stagecoach was built in 1982–1983 by David and Wallace. Wallace was fascinated with the Concord stagecoach's leather strap braces, giving them a swinging motion instead of having them jolt up and down like a spring suspension. He thought Moon Farm needed a Concord stagecoach. David found some blueprints from a museum in Oregon, and Wallace located wheels. David drew the ribs on the floor and welded the steel frame. The above image shows the frame as it was being built. Oak paneling was fitted on the inside and outside. The finished product was a beautiful replica of a Concord stagecoach, as shown below with David (left) and Wallace. It was placed in the Carriage House at Moon Farm. The stagecoach was also borrowed by the Museum of Western Colorado and used in a Wild West exhibit during the 1990s.

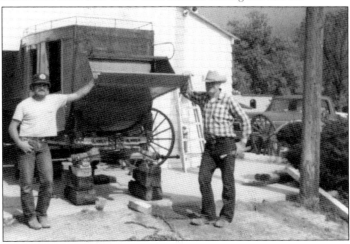

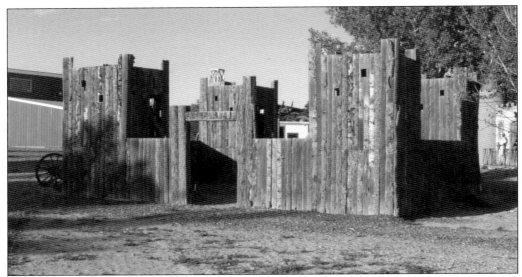

FORT APACHE, 1980. Fort Apache was built in 1980. During the day-camp years, many children claimed a fort in one of the towers. They were given hammers, nails, boards, and materials to build in the tower however they pleased. A few day campers even built onto the outside of Fort Apache in the 1980s. The fort was rebuilt around 2007 by Mary Joan's sons, James and Richard Seal.

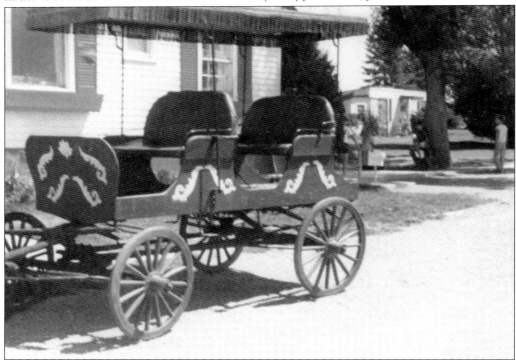

SURREY WITH A FRINGE. Ella always wanted a surrey with a fringe on top, like in the movie *Oklahoma*, so they built one. Wallace found the running gear, purchased wood, and constructed the surrey. Ella completed it by adding the fringe on top and painting designs on the side. It can be seen in the Carriage House with two doctor's buggies, a Concord stagecoach, saddles, and various other tacks.

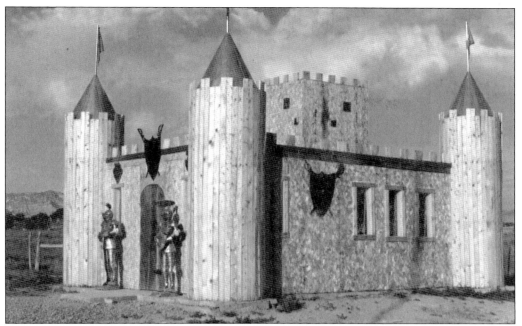

THE SPANISH CASTLE, C. 1985. Ella had been researching old Spanish castles and wanted one. Wallace and his niece Renee Workman built her a castle but did not add the moat and drawbridge she requested. However, Ella was satisfied with her two knights in shining armor. Three turrets and one enclosed battlement were also constructed. There were many shields, swords, and framed pictures of Spanish castles on the walls. Ella wanted to teach children the story of Christopher Columbus, so she dressed mannequins as King Ferdinand, Queen Isabella, and Columbus. David painted a scene of the Old World, complete with sea monsters and the *Niña*, *Pinta*, and *Santa Maria*. In 2000, stucco was added to the outside. Cultural programs on Spain were taught in the castle during the day-camp years. In 2011, the Spanish Castle was transformed into a haunted house.

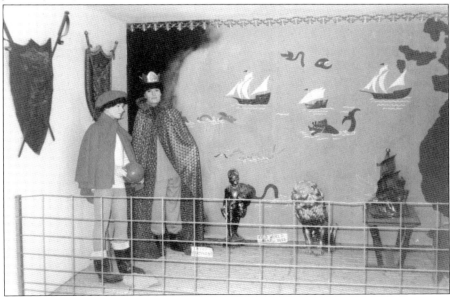

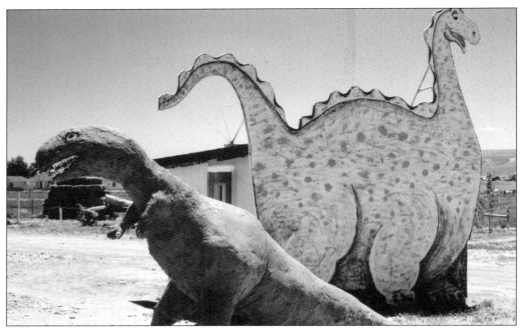

THE DINOSAUR AREA. Moon Farm's T-Rex was made with the help of day campers in the late 1970s. It has been patched and repainted many times throughout the years. The dinosaur museum was built in 1988. The mural inside was painted by David. Ella's framed dinosaur painting still hangs on the wall. The showcase displays different fossils, including clam fossils found by day campers in Moon Farm's fossil pit.

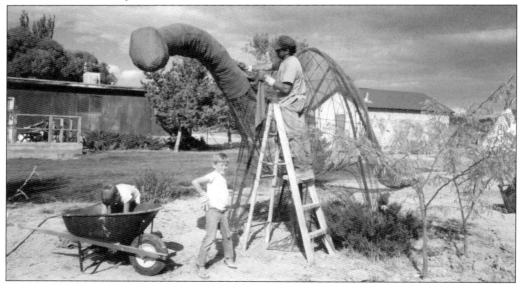

BUILDING THE APATOSAURUS. David started to construct his apatosaurus in the fall of 1991. It was built with steel tubing, chicken wire, and burlap. In this picture, David's nephews James (left) and Richard Seal are dipping burlap in cement and handing it to David (on the ladder). Since winter was approaching, a plastic tent was erected over this 40-foot dinosaur so work could continue. It was finished in the late spring of 1992.

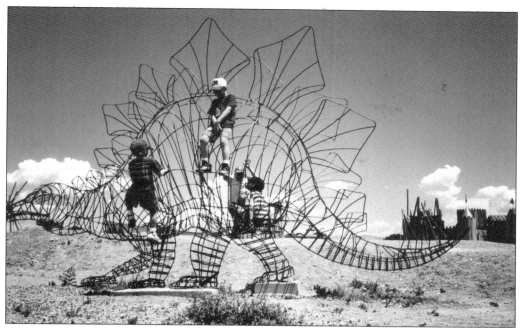

STANLEY THE STEGOSAURUS. Moon Farm's dinosaur jungle gym was created by Richard Fredette with welded metal rods. He started building the stegosaurus in 1984 and finished 14 months later. Stanley was delivered to Moon Farm during day camp in the summer of 1985. He was also displayed on Main Street in Grand Junction as part of Art on the Corner from May 1986 to May 1987.

SARA THE SAFETY-SAUR-US. In 2001, Chris Hollandsworth from Saint Mary's EMS Outreach program approached David to design and sculpt a foam dinosaur for the Safety-Saur-Us Injury Prevention Project. This picture shows the painted foam triceratops that David sculpted on an ambulance. The internal organs were engineered by Brad McKee, Forrest Hoskins, and Marc Coutu. Sara was used to teach children about safety. She is now parked in front of Fruita's Dinosaur Journey.

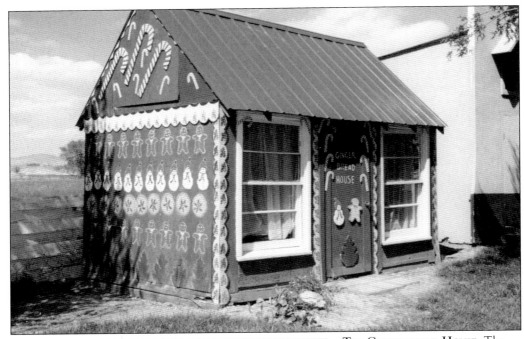

The Gingerbread House. The Gingerbread House was built in 1993 because Ella wanted to celebrate Christmas all year long. She painted the east and west outside walls with Christmas designs. The inside included three decorated Christmas trees and several wreaths made by Ella. She also saved old Christmas cards and used them for wallpaper. Wallace constructed a fake fireplace, and Ella dressed dolls as Santa and Mrs. Claus to complete her décor.

The Beauty Salon. A beauty salon was built next to the playhouse in 1979 for Moon Farm day campers to enjoy. It was a small, simple building with a counter facing the mirror, chairs, combs, brushes, and an old hair dryer. In 2016, it was refurbished. An antique couch was donated from a private beauty salon. Two old salon chairs, a sink, and vintage equipment were also added.

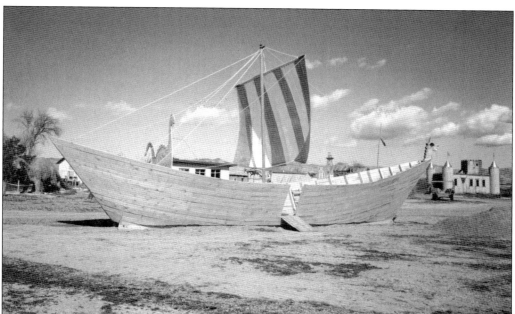

THE VIKING AREA. Ella enjoyed telling people her ancestors were Vikings from the Isle of Man. Because of her Viking heritage, Ella needed a Viking ship. During the fall of 1989, David designed a ship and drew up the blueprints. That winter, Ella's brother Ed and Wallace built it using David's blueprints. While the Viking ship was being moved to its destination with the old tractor, it hit soft dirt and came to a halt by the parking lot—it still stands there today. A few years later, a small log house was donated to Moon Farm; Ella transformed it into the Viking House. She painted a picture and a Viking alphabet on a piece of wood, and both were hung on the wall. A Viking mannequin stood in the corner, and a table with two chairs was set by the door.

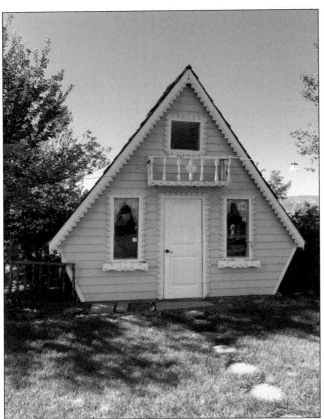

THE SWISS A-FRAME. The yellow A-frame building on the south end of Moon Farm's property was built in 1990. Ella called it the Swiss Chalet. It was used for a reading room at the day camp as well as an office/headquarters for Moon Farm's pumpkin patch. The outside had a faux balcony and white gingerbread lining the A-frame windows and door. Wallace cut the gingerbread pattern on his jigsaw, and Ella painted the flower pattern. The flowers were repainted around 2014 by Jannae and Taryn Moon. The showcase contained music boxes, and Ella displayed her paper cuttings on the wall. She also meticulously painted children's 1970s Wonder horses, rocking horses, and spring bouncy horses with beautiful designs. Wallace mounted them on old lampposts, and they became a carousel centerpiece. The horses are now mounted on the wall.

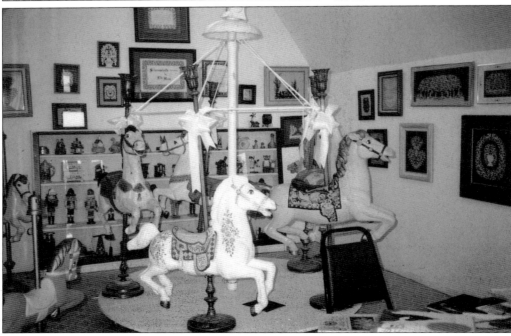

The Old Woman in the Shoe. The Old Woman in the Shoe house was built by David with the help of a few day campers during the summer and fall of 1997. There were several steps involved in this project. David drew Ella's idea on paper for them to discuss. After that was settled, construction started. Day campers helped hammer nails, erect walls, and install windows. Pieces of plywood were cut to look like a shoe and fastened to the building. The above picture shows the plywood shoe after David and the day campers nailed it onto the house. During the fall, David finished the shoe by applying stucco and paint. David is shown with the completed project in the picture at right.

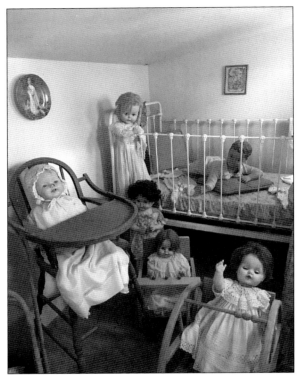

ANTIQUE ITEMS IN THE SHOE. Ella knew exactly what she wanted inside the Old Woman in the Shoe house. She dressed a mannequin as the old woman that lived in the shoe. Ella placed the mannequin and a collection of antique baby furniture, complete with old dolls, behind the fence. They are shown in the picture at left. Showcases displayed Ella's 1919 baby shoes, David's 1962 shoes, and David's daughters' 1994 shoes. Not only does the shoe hold three generations of the family's baby shoes, but Wallace Moon's 1914 baby clothes also hang on the wall. The below photograph shows Ella and David's shoes and Wallace's baby clothes.

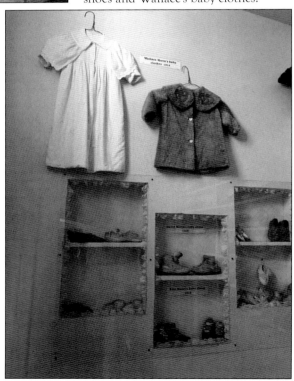

David's Shop and Statue. The shop built onto the carriage house in the year 2000 is pictured above. It was used for farm projects, and David also ran a small company called Moonscapes in the shop. He sculpted signs and pieces of art by hand using foam, then he hard-coated and painted these pieces. One example is the sign at the entrance to Banana's Fun Park in Grand Junction. In 2002, David and his business partners opened a new company named Moonscapes 3D. It was a 3D enlarging company for bronze sculptors that utilized a digital laser scanner and a 3D CNC milling machine. Artists from all over the country sent art pieces to Moonscapes 3D to be enlarged. The below image shows a foam reproduction of D. Michael Thomas's sculpture of Chris LeDoux called *Good Ride Cowboy*.

THE MOTHER GOOSE HOUSE. This is the 1999 playhouse with a porch donated to the farm. It was placed near the schoolhouse and transformed into the Mother Goose House. Ella cut nursery rhymes out of an old book, glued them to the wall, and made curtains. David created a foam sculpture of a flying goose and hard-coated and painted it, while Ella dressed a mannequin to sit on the goose.

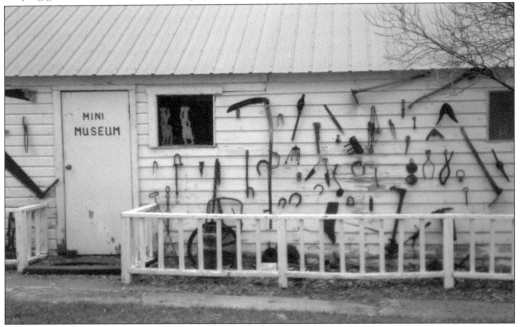

THE MINI MUSEUM. The Mini Museum displays several different collections, including Avon bottles, shells, rocks, driftwood, and old cameras. The showcase in the museum exhibits antiques like a gas iron, ice-cream freezer, butter mold, toaster, and many more items. The museum also contains old typewriters, antique sewing machines, old bag cell phones, and several other antiques. The green 1970s shag carpet is from Jannae (Jens) Moon's childhood home.

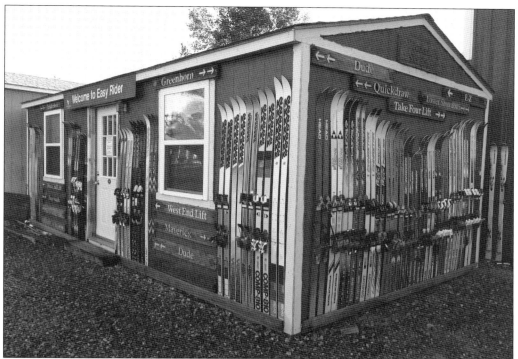

SKI AND SNOWBOARD MUSEUM. The building that housed David's ski and snowboard collection was an office for Moonscapes 3D. Today, it is once again an office—for Grand Valley Equine Assisted Learning Center. However, for approximately 10 years in between, visitors enjoyed looking at old skis, snowboards, and other vintage equipment. Some were from Powderhorn Ski Resort on the Grand Mesa. David worked at Powderhorn as a ski instructor, ski patroller, and snowcat driver for over 20 years. One corner inside the museum even displayed the old ski patrol desk from the patrol shack on top of lift one. The above picture shows the outside of the museum with old signs for some of the runs at Powderhorn. Pictured below is the inside, with David's personal collection of antique skis, snowboards, and other miscellaneous items.

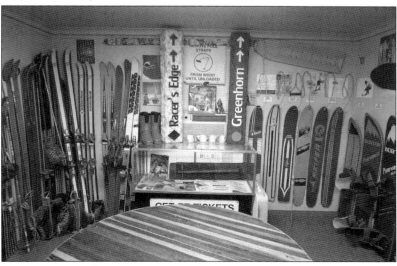

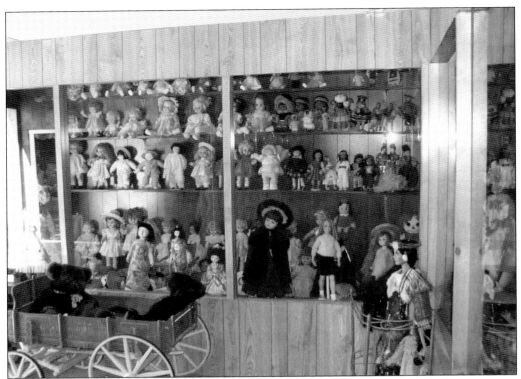

DOLLS AND BARBIES. The doll collection was added to Moon Farm over time. The first room was built in the late 1970s. Ella purchased most of the early dolls. The above image shows only a small sampling of her dolls. There are three more large showcases full of various dolls that were bought and donated. The milking shed/carpenter shop was transformed into a Barbie room in 2014. It was called "phase one," because Kathy Erickson donated so many Barbies that they could not all fit in one room. Below is the north wall of phase one displaying celebrity Barbies. David also built a showcase in the center of the room. Behind the glass are Bob Mackie Barbies and bride Barbies. In 2015, phase two was completed by changing the garage into another Barbie room. There are thousands of Barbies in this collection.

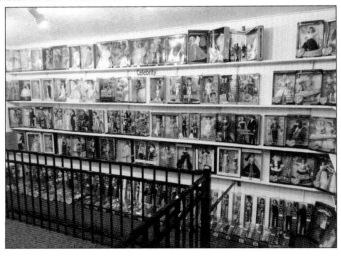

Four
Fun on the Farm

MOONS GREETING FRIENDS. There was always something fun happening at Moon Farm. Usually, Wallace and Ella were engaged in a project. However, they would take time out to entertain. Ella constantly planned elaborate picnics and parties, while Wallace trained and hitched his horses for rides around the farm. Wallace (left) and Ella (center) are shown with some friends. Betty Elliott is on the right. (Courtesy of Betty Elliott.)

MOON FARM PICNICS. Wallace and Ella hosted many picnics at the farm, including the one pictured. The earliest were the annual Adoption Day picnics. These outings commemorated Ella and Wallace adopting their children. Ella first invited the community around 1963. The newspaper usually drafted an article to invite those with adopted children and anyone interested in adopting. Each year, there were approximately 120 participants.

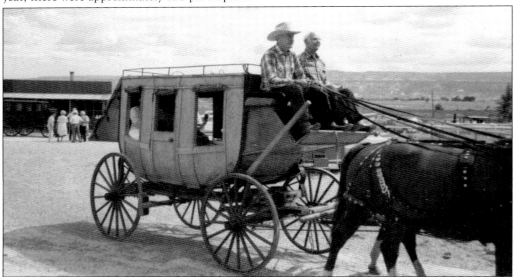

WALLACE ENTERTAINING FRIENDS. This picture shows Wallace (left) giving a stagecoach ride to friends. In the background are several other friends standing near the carriage. It was not unusual to see Wallace with his horses hitched to the stagecoach, carriage, buggies, or surrey with the fringe on top. He thoroughly enjoyed the days he could give people rides using his horses and horse-drawn vehicles.

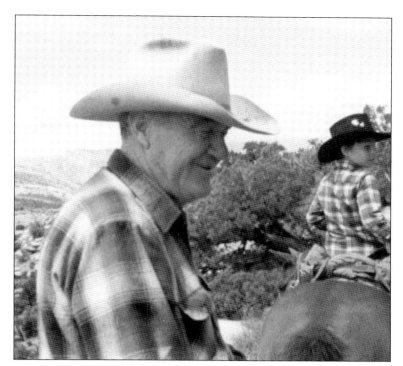

HORSEBACK RIDING FOR FUN. Wallace did not leave Moon Farm for outings very often. However, since he loved riding horses, he would occasionally go for a ride beyond the farm. One destination was the desert north of Moon Farm, since it was easy to access. This picture shows Wallace (in the foreground) on a longer ride to Rattlesnake Canyon. His niece Renee Workman took this picture. (Courtesy of Renee Workman.)

TOURING THE FARM. One of Ella's favorite activities was showing friends and visitors around Moon Farm. According to friends of the Moons, they could not wait to see what new project Ella and Wallace had most recently finished. This photograph shows Ella's friends from St. Bridget's Circle admiring the male peacock atop the log cabin. Ella loved birds and always allowed peacocks to freely strut around the farm.

St. Bridget's Christmas Parties. When Ella was around 60 years old, she started inviting her St. Bridget's church group ladies and their husbands to a Christmas party on the farm. In preparation, Ella sewed party favors as gifts for each person attending. The above picture shows Ella's handsewn cowboys and cowgirls. The men received a cowgirl from Santa Claus (Roland Marasco) while the women were given a cowboy from Mrs. Claus (Billy Abel). Ella also sewed the Santa Claus costumes. The below image shows nine years of gifts sewn by Ella—without using a pattern. After dinner, Wallace would hitch his horses to the hay wagon for a ride down the country roads. The party culminated with Ella's homemade pies being served in Great Granny's House. The Moons hosted at least 50 people each December from about 1978 to 1987.

Moon Farm Birthday Parties. Moon Farm has hosted hundreds of birthday parties over the years with thousands of attendees. Pictured is a birthday party held on the back patio of the farmhouse. Parties could also be held at the picnic area near the slide or pumpkin patch. There was plenty for kids to do, including exploring Moon Farm, petting farm animals, and taking a train ride or hayride.

Church Service and Picnic. For about 10 years in the early 2000s, Fr. Mike Smith from Sacred Heart in Fruita held an August Mass at Moon Farm. When the service was over, there was a potluck picnic on the back patio. After lunch, adults could enjoy perusing museums on the property. Children were allowed to swim in the wading pools, play around the farm, or do some target practice with BB guns.

Moon Farm Express. The Moons bought a train from Grand Junction Regional Center in the early 1980s. It was named Moon Farm Express and driven down Fruita's country roads by Wallace and David. They gave rides to friends, day campers, and birthday party attendees. The train was also used in Fruita parades, on International Days, and as a decoration for the pumpkin patch. Wallace is pictured with his grandsons James (left) and Richard Seal.

Farm and Ranch Days. Wallace and Ella participated in Farm and Ranch Days on Main Street in Grand Junction. The Moons brought various animals each year. Sometimes, the pony wheel was utilized so children could experience riding a pony. In other years, a calf or goat was taken to pet. Occasionally, smaller animals such as bunnies or baby chicks were placed in the petting area.

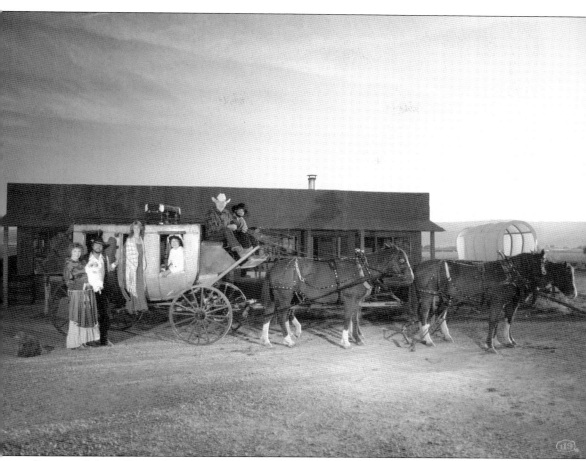

CREATIVE MOON FAMILY PICTURES. Not only did Wallace give friends rides in his horse-drawn vehicles, he also enjoyed taking family members around the countryside. After Wallace and David had just finished building the Concord stagecoach, Wallace hitched up his team of four horses, and Ella made sure the family members living in town at the time were dressed in 19th-century attire. Ella hired Dave Canaday from Studio 119 to take this photograph in the fall of 1983. Wallace is driving the horses, with David sitting next to him. Ella is in the stagecoach, and David's wife, Jannae, is standing in the door of the stagecoach. Bob and Mary Joan Seal are at left, with Mary Joan holding their baby, Ashley. The stagecoach was also taken to the desert north of Fruita for some photographs. When Canaday passed away, the Moons bought his antique camera collection from his wife, Vicki. The cameras are displayed in the Mini Museum.

CHRISTMAS PAGEANT TRADITION. Around 1966, Ella re-enacted the Christmas story during her Christmas Eve celebration. She dressed David and DiAnn as Mary and Joseph, as shown above. Ella asked Wallace to read the Christmas story from the Bible. This developed into a tradition that became more elaborate each year. Ella recruited adults when needed, friends' children, and even newborn babies to portray baby Jesus. One year, she brought real barnyard animals into the living room for the pageant. No matter how many children came to Christmas Eve, Ella sewed a costume so they could be included. This tradition continued for more than 50 years—from 1966 to 2020. Christmas Eve 1995 is pictured below.

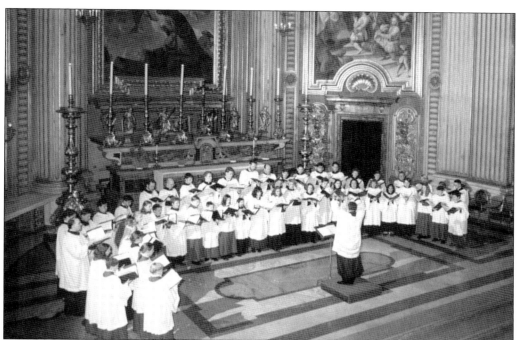

MADELEINE CHOIR SCHOOL. In 1998, Ella's niece Talitha Day asked her to sew surplices for her son's choir. She sent Ella one as an example. Ella took it apart to use for her pattern—that was all she needed to begin the project. She sewed 108 surplices in three weeks and shipped them to Salt Lake City. The Cathedral of the Madeleine Choir School from Salt Lake City traveled all over Italy and even performed at the Vatican for Pope John Paul II in February 1998. In fact, the choir still uses her surplices today. Choir members have traveled to Germany, Belgium, Spain, Italy, and England wearing Ella's handiwork. The above picture shows the Madeleine Choir. The picture of Marc Day with Ella shown at right is hanging in the Moon Farm Church. (Both, courtesy of Talitha Day.)

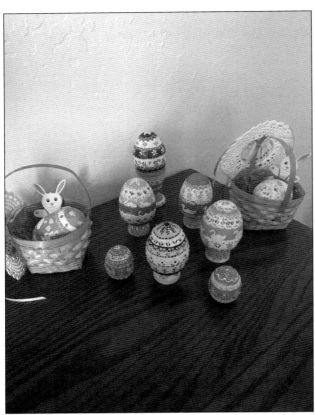

ELLA'S FABERGÉ-STYLE EGGS. In the 1980s, Ella was reading about the Russian Fabergé eggs of the 19th century. She thought it was fascinating how they were gifts to the tsars. She decided she could paint the filigree eggs and gift them. Ella bought wooden eggs and special paint at the craft store. David made Ella's painting tool from small syringes. She painted many eggs over the next 20 years.

GERMAN SCHERENSCHNITTE. Ella's grandma Eliza Curfew taught her the German art of delicate paper cutting using her small scissors. Ella practiced this art form from age five until she was in her nineties. Many evenings at the farmhouse, Ella cut her scherenschnitte while watching the news. She was so skilled that she often cut scherenschnitte cards and mailed them to family and friends. Some of Ella's scherenschnitte once decorated the walls of the Swiss Chalet, as shown below.

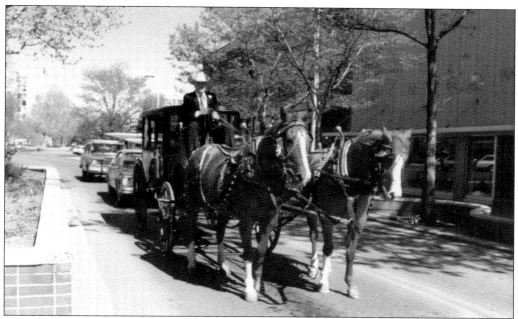

FAMILY AND FRIEND WEDDINGS. Wallace would often use his carriage and horses for the weddings of family and friends. A close family friend, Betty Elliott, recalls Wallace driving up to their house in Grand Junction with his carriage for her daughter Mary Ann's wedding. Wallace would dress in his finest suit with either a cowboy hat or a top hat. He enjoyed taking the bride and groom on a tour around town. Above, Wallace is driving David and Jannae Moon down Main Street in Grand Junction after their 1984 wedding. In the 1985 picture below, Wallace has just taken Jeff and Denise Over from the Methodist church in Fruita to the home of Jeff's parents, Jim and Carol Over, across the road from Moon Farm. (Below, courtesy of Jeff and Denise Over.)

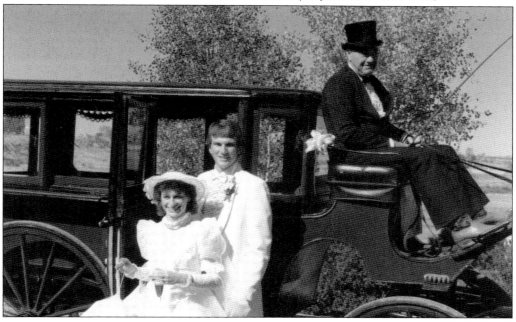

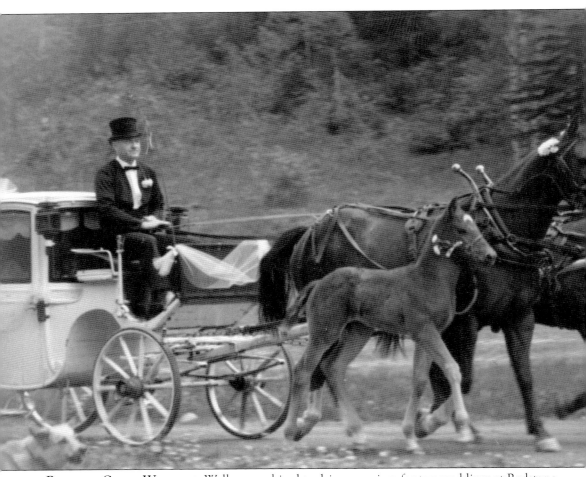

REDSTONE CASTLE WEDDINGS. Wallace was hired to drive a carriage for two weddings at Redstone Castle in Redstone, Colorado. This picture is from one of the weddings. The other wedding was in August 1977. Wallace knew it was for someone famous but did not know who, because it was very secretive. Only after the family arrived at Redstone Castle did they find out it was Jimmy Buffett. Wallace used his horses hitched to Redstone Castle's carriage. Wearing his suit and top hat, he drove to the castle and waited by the covered entryway for the wedding to end. After the wedding, Buffett and his new bride, Jane, came out and got into the carriage. Wallace drove them around the grounds. When they returned to Redstone Castle, the Moon family was able to attend the reception. They remember sitting on the stairs and listening to famous bands such as the Eagles as they performed live.

COMPANY PARTIES. During the 1980s and 1990s, David Moon made a brochure to pass out among businesses advertising Moon Farm as a venue for company parties. Several business owners scheduled gatherings for their employees and families. David set up a volleyball court and horseshoe pit. The above image shows guests at one of the company parties playing volleyball. Wading pools, the petting zoo, and playhouses were open for children to enjoy. Some companies hired a catering service, and others made their event a potluck picnic. One company even hired professional actors (pictured below) to reenact scenes from an Old West shoot-out for their company picnic.

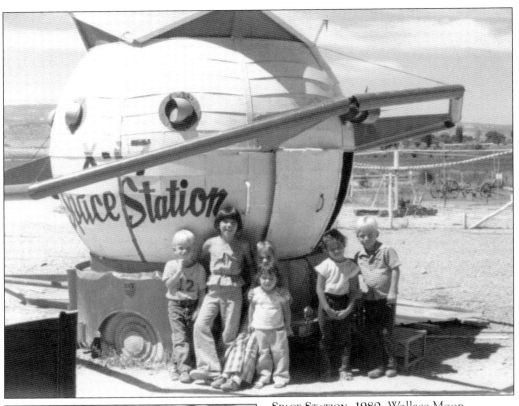

SPACE STATION, 1980. Wallace Moon acquired the space station from an auction in Delta, Colorado, during the 1970s. The space station was a fun addition to Moon Farm because it rotated in circles and gave children a ride. The day campers enjoyed lining up for a spin in the spaceship. (Courtesy of Pam Morris.)

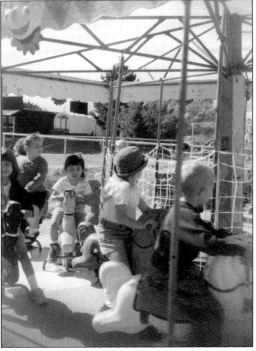

MECHANICAL CAROUSEL. The mechanical carousel was bought in the 1970s. Children loved to ride the colorful horses. Because it was a favorite among the younger children, counselors at the day camp used it for five- and six-year-olds quite often. It was located next to the spaceship, so one counselor could run both at the same time. Ella repainted it several times. Unfortunately, it was torn down in 2015.

BUCKING BULL. David made the bucking bull around 1974 to practice with his friends before their rodeos. It was placed in the field close to the farmhouse. The bucking bull was later relocated near the obstacle course for visitors to enjoy. Many children have been bucked off the Moon Farm bucking bull. This picture was taken during the day camp years.

THE NEW DANCE STUDIO. Dance lessons were a staple at Moon Farm from 1954 to 2008. Ella and DiAnn taught classes in the basement until a small studio was built on the property in 1975. Ella continued to teach dance in the basement, but DiAnn taught in the new studio/clown house. Julie Morris is the child at the center of this image. When day camp started, DiAnn taught dance on the patio. (Courtesy of Pam Morris.)

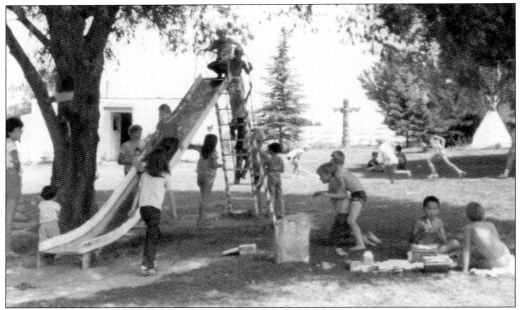

THE OLD METAL SLIDE. The metal slide at Moon Farm came from a public swimming pool in the 1970s. Thousands of children have enjoyed this fast metal slide over the years. It was even used as a waterslide on hot days at the day camp. Picnic tables were placed by the slide early on. This picture illustrates the popularity of this area. (Courtesy of Pam Morris.)

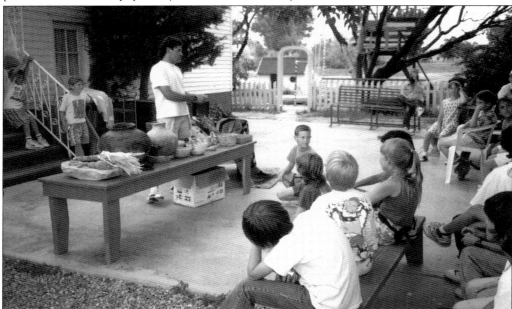

SCHOOL PRESENTATIONS. David Moon is shown giving a Native American presentation to a group of fourth-graders. Most field trips were end-of-the-year picnics or graduations for preschoolers and kindergartners. However, on occasion, older elementary-school classes would come to Moon Farm. David owned a personal collection of Native American artifacts. Using his and Moon Farm's artifacts, he would conduct presentations.

Five

DAY CAMP LIFE

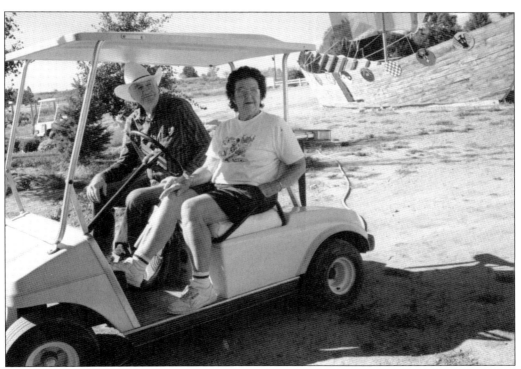

DAY CAMP, 1976 TO 2008. Moon Farm Day Camp ran for 32 years with an average of 150 children attending each weekday during the summer. Wallace (called "Mr. Moon") oversaw the horse program, fort-building, and driving the train until he passed away in 1995. Ella ("Mrs. Moon") was the director, organized camp activities, and taught arts and crafts for the entire 32 years. She was 90 years old when the day camp was retired.

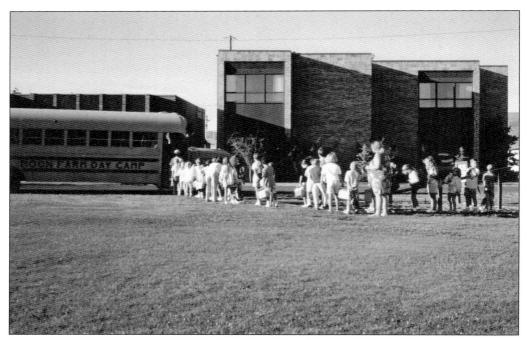

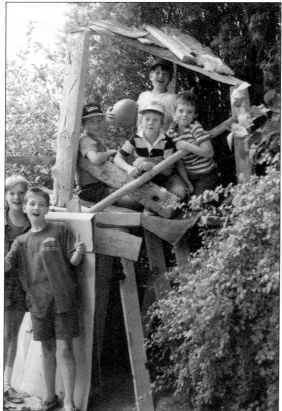

MORNING AT SHERWOOD PARK. This picture shows day campers lining up to board the Moon Farm bus at Sherwood Park. Those who lived in Fruita could drop off their children at the farm anytime. However, most day campers came from Grand Junction, since Fruita was a small community back then. Buses arrived at 7:30 a.m. and 8:30 a.m., along with vans for overflow. The ride to Moon Farm took about 30 minutes.

BUILDING FORTS. If day campers wanted to build their own fort/clubhouse, a counselor handed them a hammer, nails, and wood. They chose a location and started building. In the early days, Fort Apache was even built onto by campers. Sometimes, a junior counselor helped them or checked out their handiwork. All forts were inspected daily by Wallace, David, or another counselor. The clubhouse pictured here was built across from the treehouse.

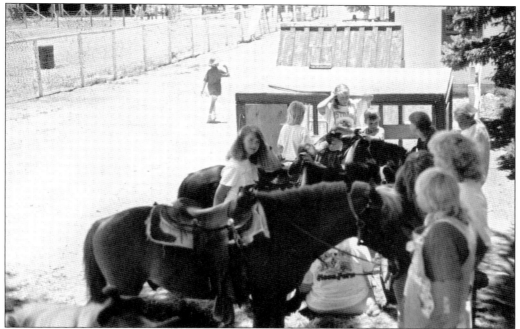

HORSEBACK RIDING. The above picture shows counselors and campers saddling horses for trail rides around Moon Farm's hayfield. Other day campers formed a line outside the arena to wait their turn to ride a pony. If a child was new to horseback riding, they were given a quick lesson. Wallace told them to hold the horn so tightly that it would go with them if they fell off. The riders were led by junior counselors or older campers, with Wallace bringing up the rear. Quite often, he could be heard singing, humming, or whistling around the field. Wallace rode until about 1993. His niece Renee Workman took over the horse program, and other counselors were hired later. Below, day campers are shown heading out for a trail ride.

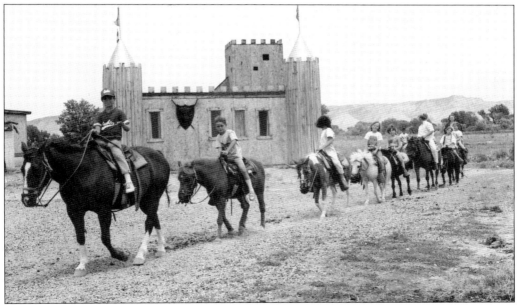

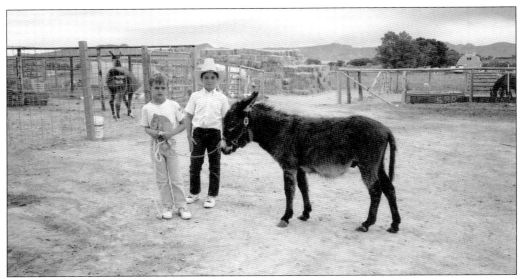

WALKING BULLET. One barnyard activity at Moon Farm was walking the donkeys. After receiving permission, campers could halter, leash, and walk the donkeys. These campers are walking Bullet. Friends/neighbors Chris Harmon and Suzanne Ratchner adopted and cared for Bullet during his final years. They kept him at the farm for people to enjoy. He was the longest-surviving animal involved with the day camp and passed away in August 2022.

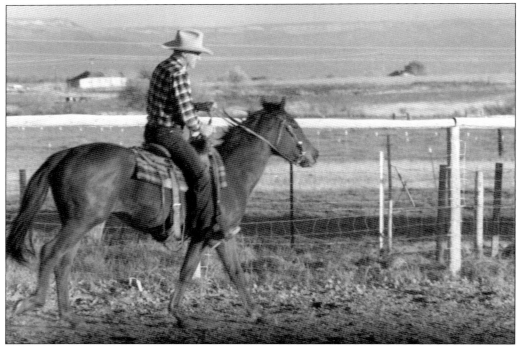

MR. MOON BREAKING HORSES. Wallace Moon was an excellent horseman and loved his horses. In Jensen, Utah, he herded cows on horseback and farmed using horses. At Moon Farm, he broke them to ride and to pull his horse-drawn vehicles. This photograph shows Wallace helping his niece Renee (not pictured) break her horse in the Moon Farm arena. (Courtesy of Renee Workman.)

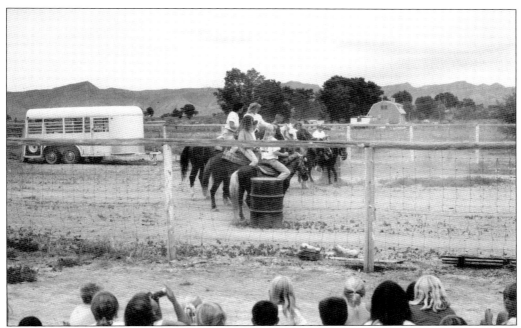

MOON FARM RODEO. The annual rodeo was a Moon Farm tradition. Day campers who enjoyed horses and wanted to show off their skills signed up to participate. Practice was usually right after lunch. The events included barrel racing, egg racing, and flag racing. There were even rodeo clowns to move the barrels and entertain the crowd. On the day of the rodeo, the entire camp, as well as parents, lined the arena and cheered on their favorite horse and rider. Trophies of horseshoes with ribbons and painted plaster horses were given to the kids with the fastest times. The above picture shows campers participating in a rodeo while other day campers watch. An awards ceremony is pictured below.

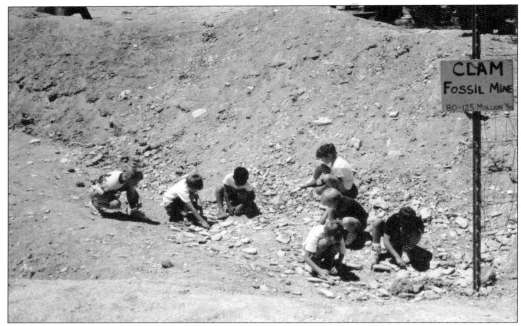

FOSSIL PIT. One camp activity was digging for clam fossils, as shown above. The Moons noticed a shale formation on the farm. They dug down with a backhoe and found Mancos shale. The ground contained clam fossils, fish scales, and shark teeth. Since kids love to dig, this was the perfect activity for them, as they could find authentic fossils. Day campers were given a hammer and shown what to look for. When campers found relics, a counselor sprayed them with a clear coat, and the preserved fossil could then be taken home. Campers who found relics also earned a ticket to spend at the Country Store in the afternoon. A few campers left their finds to be exhibited in the dinosaur house, as shown in the below image.

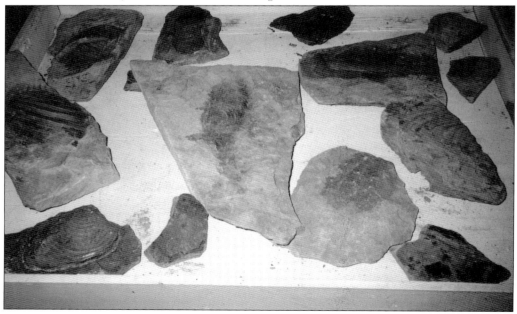

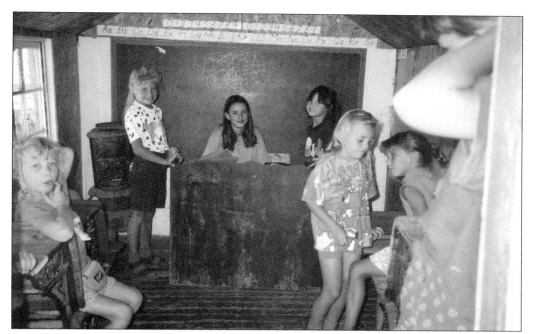

Playing School. Visitors, school groups, and day campers loved to play school in the little red schoolhouse. Hundreds of children remember taking turns pretending they were the teacher. Ella Moon even supplied real chalk for the chalkboard. During day camp, children were able to play in the schoolhouse during free time, as shown in this picture.

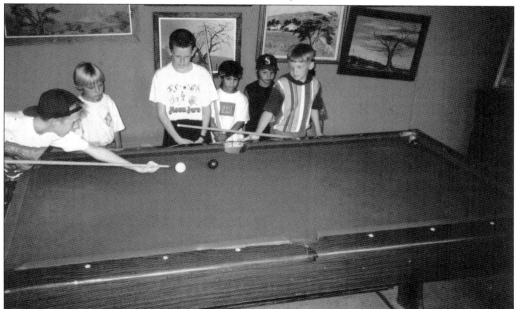

Pool Room. This picture shows day campers playing pool in the clown house. The Moons received the pool table from Fruita's Sacred Heart Church, where it was in the basement during the time Ella Moon taught catechism classes. Notice her oil paintings on the wall behind the day campers. One of Ella's many talents was painting. Dozens of her landscapes were hung in the clown house.

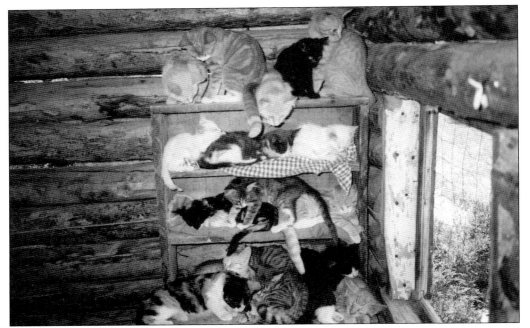

BABYSITTING KITTENS. At one point during day camp, there were many kittens for the day campers. Somehow, babysitting kittens in the log cabin became a morning routine. The babysitters would announce their babysitting business on the PA system and charge a ticket for their service. Campers could drop their kittens off and go play. This picture shows the cupboard Wallace made for the log cabin full of kittens.

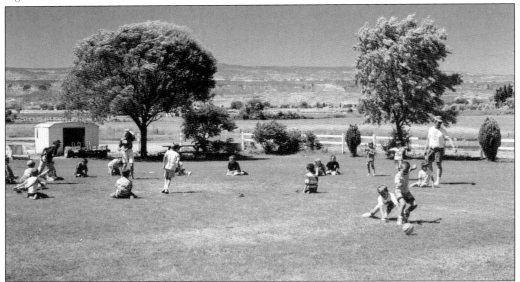

MORNING ATHLETICS. There was a large grass athletic field south of the farmhouse, as shown in this picture. Each year, the Moons hired an athletic director to organize morning athletics and afternoon water play. The athletic director coordinated games for five- to eight-year-olds from 9:00 to 10:00 a.m. From 10:30 to 11:30 a.m., the older day campers had their turn. Some of the more popular games were kickball, capture the flag, and freeze tag.

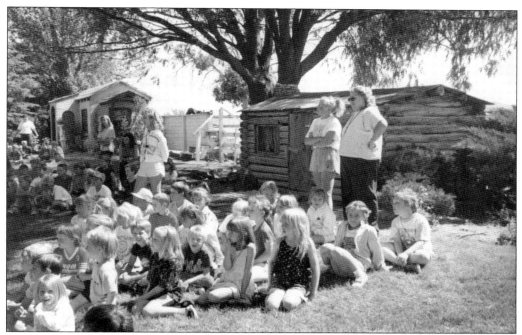

RAISING THE FLAG. At 10:00 a.m., everyone at camp gathered on the lawn by the log cabin. Each age group was assigned a counselor and a junior counselor. Every day included raising the flag, reciting the Pledge of Allegiance, roll call, and rules. Ella Moon led the pledge and reminded campers of the rules. She also dismissed everyone to their morning activities. The seven-year-old group is pictured in the foreground of this image.

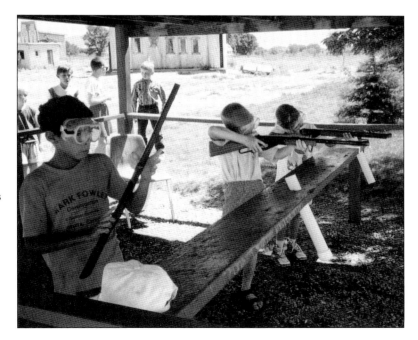

BB GUNS. One morning activity involved shooting BB guns at aluminum cans. Before shooting, participants received a lesson on gun safety. They then lined up and had five shots each. There were three guns and many cans set up. When all of the cans had been knocked down, the current shooters locked their guns into safety position, set them on the shelf, and replaced the cans.

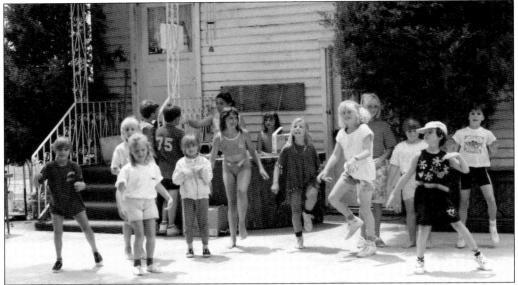

DANCING ON THE PATIO. After flag-raising, DiAnn and other teachers/counselors taught dance on the patio. Sometimes, the campers would learn short dances and perform them for the day camp after lunch. Full-time day campers would also practice on certain mornings for the annual dance show that parents were invited to attend. This picture shows the free dance sessions offered in the afternoon on certain days.

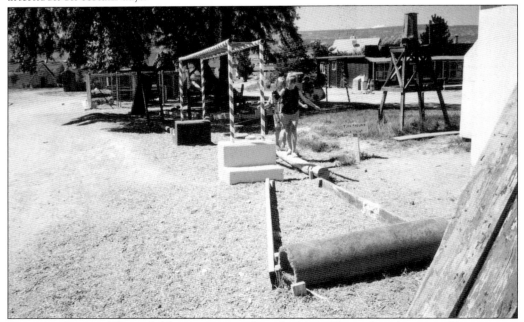

OBSTACLE COURSE. These children are pictured on the Moon Farm obstacle course. Day campers often practiced walking the obstacle course without falling off. When they had mastered that, the campers found a counselor to watch. If they walked the entire course without losing their balance, they earned a ticket to spend on popcorn, Dum-Dums, Kool-Aid, or toys at the Country Store. The store usually opened around 2:00 p.m.

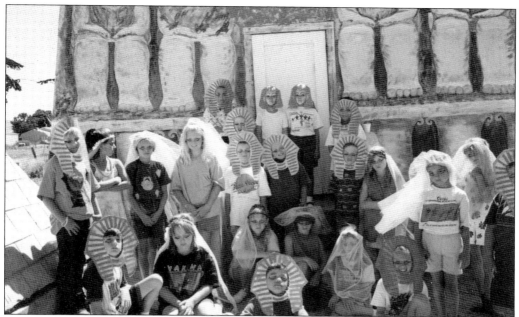

CULTURAL PROGRAMS. Many buildings around Moon Farm represented different peoples and their cultures. Ella Moon encouraged day campers to learn about various regions and societies. Ella's summer list of cultural programs covered the Middle East, Spain, Native Americans, pioneers, and Vikings. The above picture shows day campers dressed as Egyptians. The children were taught about ancient Egypt and wrote a cartouche using crayons and the Egyptian alphabet. The below image shows the cultural program held in the Spanish Castle, which included a short presentation about Spanish culture and the story of Christopher Columbus. The four campers standing up are dressed in Spanish dancer costumes. Ella made the boys' costumes, and the dresses were donated by Ella's niece Cara Curfew; Cara wore them in a Spanish dance program while living in Spain.

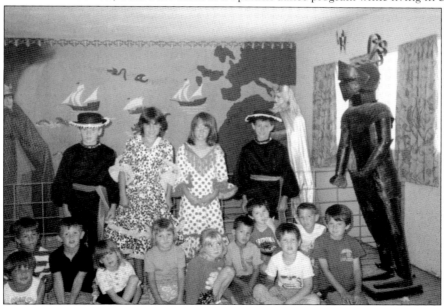

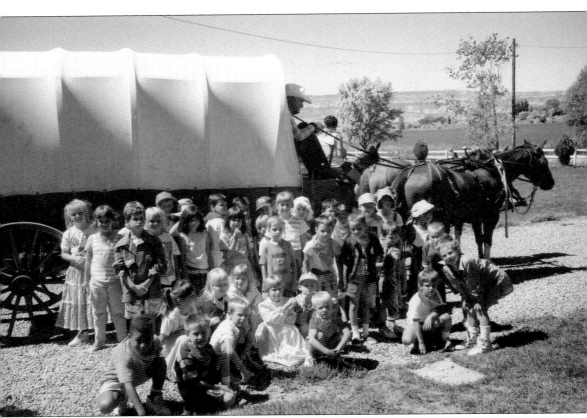

THE PIONEERS. Wallace Moon is shown sitting in the covered wagon ready to take five-, six-, and seven-year-old day campers on a ride to the desert for an activity Ella Moon called the Indian Raid. Counselors dressed the younger day campers as pioneers before heading to the desert north of Moon Farm. The five- and six-year-olds rode in the covered wagon, while the seven-year-olds walked behind it. Wallace drove them up the hill to look for gold; Ella had spray-painted gravel a gold color and spread it in the desert. After finding the gold, they continued to a designated area in the desert. While the "pioneers" were eating their lunch, another group of children (wearing "Indian" headdresses) headed to the desert and hid behind the hill. Little did the "pioneers" know that the others would come over the hill after lunch to tie Wallace and other counselors to the wagon wheels.

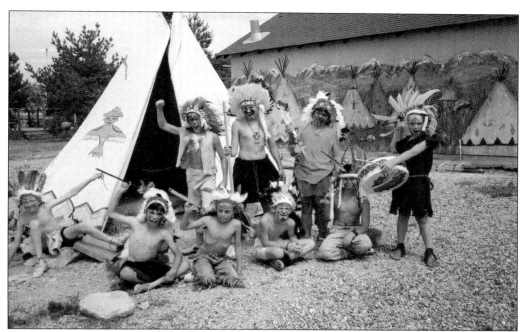

Mrs. Moon's "Indian Raid." The above picture shows campers preparing for what Ella Moon called the Indian Raid. Ella either made or purchased several headdresses, which were used for various activities at the day camp. On the day of the "raid," Ella costumed some of the campers with face paint and headdresses. Ella and another counselor would then walk these campers to the desert, where they ate their lunch and then hid behind a hill until the time was right. After another group of campers—dressed as pioneers—finished their lunch, the campers in the "Indian" costumes ran over the hill and tied the counselors to the wagon wheels. When Ella blew her whistle, the "raid" was finished, and everyone headed back to Moon Farm. The below image shows the "pioneers" in the foreground and the other campers running over the hill.

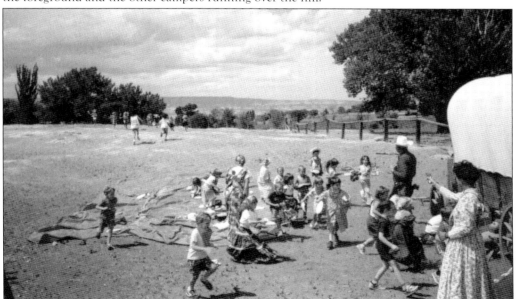

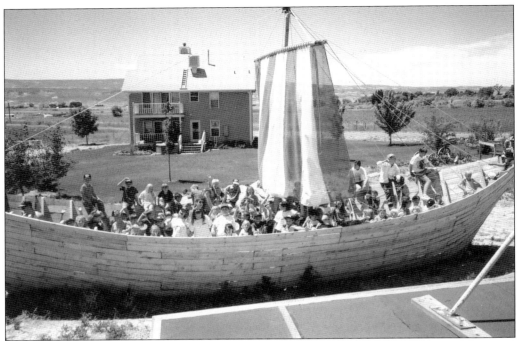

THE VIKING SHIP. During the summer of 1990, the day campers were in for a treat—Wallace and Ed had just finished building the Viking ship, and they would be the first to enjoy it. The above picture shows the entire day camp posing on the ship for a picture. With the Viking ship complete, Ella needed shields to be displayed around the exterior. Wallace cut shields out of quarter-inch plywood, and Ella enlisted older campers to paint them. Below, day campers are pretending to be Vikings. Today, the shields are still screwed to the outside of the ship. Ella repainted them with the help of David in 2012 at the age of 93. This would be Ella's last project before she passed away in February 2013.

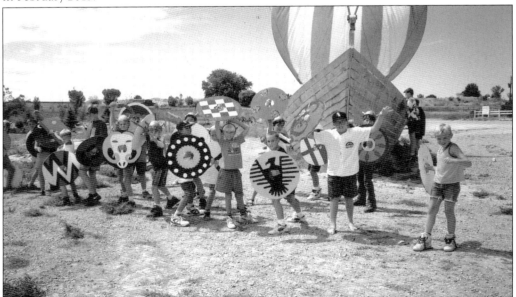

LUNCH AND TALENT. Day campers always ate lunch with their age group and designated counselor. A junior counselor was also assigned to help. Day campers brought sack lunches, and Moon Farm supplied milk. After lunch, everyone gathered at the back patio for about 20 minutes. Many different activities took place depending on the day. Sometimes, a short dance or skit, learned in the morning, was performed. Other times, campers could volunteer to tell a joke or display a quick talent. Those brave campers earned a ticket to spend at the Country Store later in the day. The picture at right shows David Moon in the background with Timmy Nichols (left) and Brendon Jens (right) performing. Counselors would also entertain the camp on occasion. Pictured below is Tana (Reed) Ingram as Sally. The campers loved it when Sally made her appearance.

97

DANCE SHOW. Each summer, Ella Moon wanted DiAnn and other dance teachers to create a dance show for parents. The campers practiced for weeks leading up to the show. One of the performances by older boys is pictured above. Memorable dances included those set to "Circle of Life" from *The Lion King*, "All That Jazz," and "Greased Lightnin'." The below image shows "Greased Lightnin'" being performed for the camp as well as parents and grandparents. Costumes made by Ella were used along with campers dressing in designated color schemes for the show. Ella would often include her Native American-style dance using headdresses and her homemade costumes.

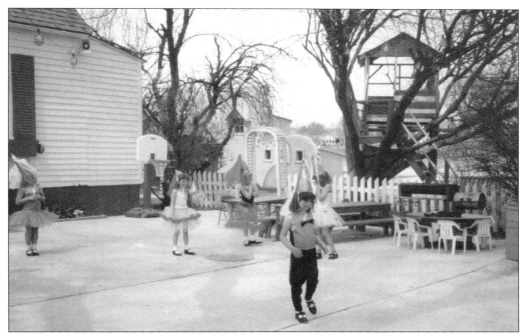

YOUNGER CAMPERS. Five- and six-year-old campers had more structure in their days than older children. Their counselors planned fun activities for them in the morning. After lunch, they went into the farmhouse living room for story time and rest. After nap time, they could play in the small pool or join another activity. The youngest campers also had their own dance in the dance shows. This picture shows younger day campers dancing.

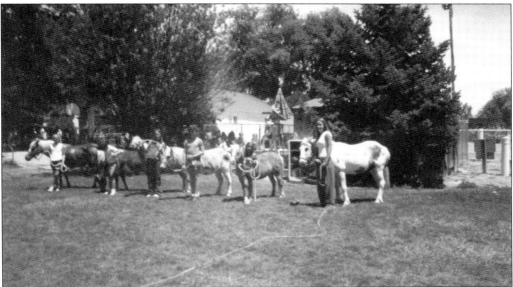

FUN WITH ANIMALS. Campers learned to cherish animals at Moon Farm. They washed, groomed, and fed various barnyard animals. This image shows campers washing down ponies on the athletic field. Ella Moon even organized a pet parade. She gave scrap material and ribbons to the participants, who dressed the barnyard animals and paraded them around the farm.

TALENT SHOWS. Ella Moon enjoyed watching children display their different talents, so she decided Moon Farm needed a talent show. Individuals or groups signed up to participate in the annual talent show. DiAnn organized the show and asked some of her friends to judge the participants. Parents were also welcome to attend the show. Prizes were awarded to the winners. This picture shows a Moon Farm air band.

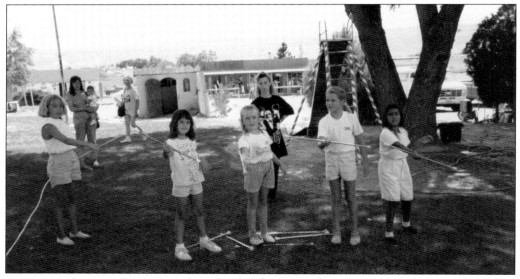

AFTERNOON LESSONS. Since it was hot after lunch, many afternoon activities were performed in the shade behind the garage. Counselors taught campers various skills, including baton-twirling (pictured) and cheerleading. Other counselors demonstrated crafts such as making friendship bracelets or plastic key chains. Campers could finish bracelets and key chains in their forts, hanging out in the shade, or at home.

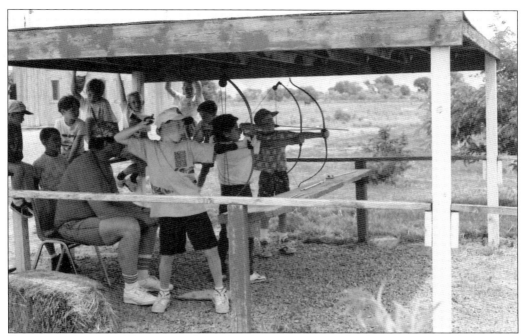

PRACTICING ARCHERY. This picture shows the afternoon activity of archery. During lunch dismissal, interested campers were accompanied by a counselor to the archery range. Targets were placed on hay bales. After lessons on safety and a demonstration, campers could then shoot at targets. When one group of three archers was finished, they put down their bows and retrieved arrows for the next group.

THE DESERT SAFARI. Two popular morning activities were toad hunts and desert safaris. On mornings when a toad hunt was scheduled, a counselor led campers to the Moon Farm pond, where they would catch pollywogs and toads. On other days, campers rode the van or bus into the desert to catch lizards. A desert safari is pictured at right. (Courtesy of Renee Workman.)

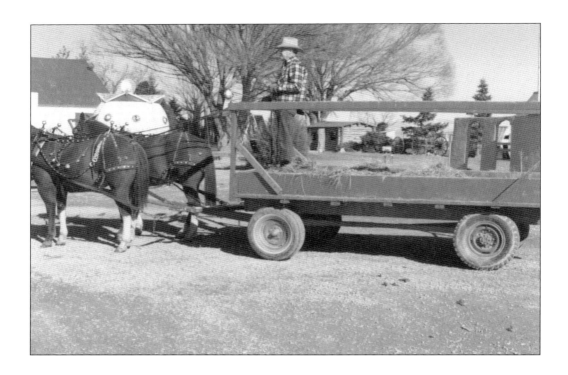

MOON FARM HAYRIDES. In the early days of day camp, Wallace Moon harnessed his horses and hitched them to the hay wagon to give campers rides around Moon Farm. Above, Wallace is shown getting ready for a hayride. During the later years of day camp, David Moon offered hayrides using the tractor. The below picture shows a group of campers on a hayride in 1999.

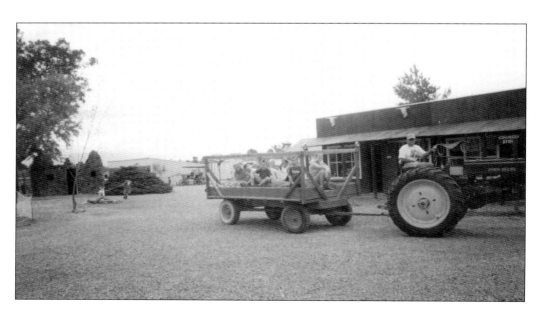

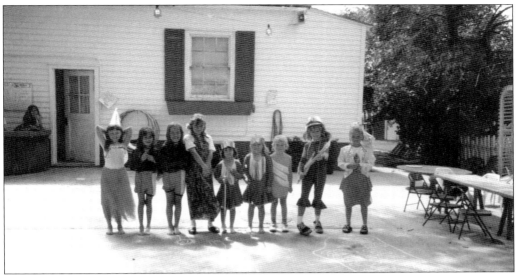

FASHION SHOWS. These day campers were participating in a fashion show. Ella Moon sewed many of the costumes worn in the show. She loved to see children enjoy wearing them. The fashion show consisted of each camper walking out and modeling their outfit while DiAnn explained the attire. After each camper had their turn, everyone came out for a final bow and applause from the audience of campers.

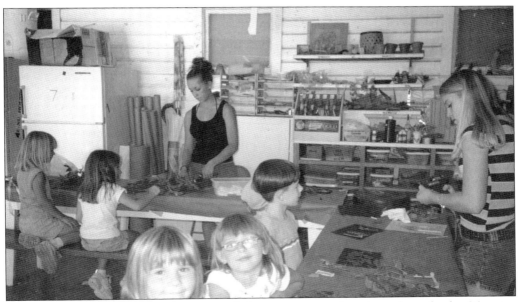

ARTS AND CRAFTS. Arts and crafts were taught by various counselors throughout the day. Morning was usually reserved for the younger children, as pictured here. Afternoon crafts were announced around 2:00 p.m. each day. The garage was air-conditioned and served as a nice place for campers to get out of the afternoon sun. Memorable crafts Ella created for counselors to teach included horseshoes on barn wood, painting ceramic figures, and decorating bark.

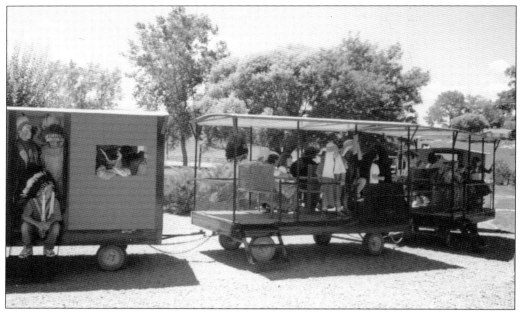

INTERNATIONAL DAY. Inspired by the cultural playhouses, Ella Moon created an annual International Day. She sewed elaborate costumes, and each participant was assigned a building to represent. The entire camp gathered to watch. The train, called International Express for that day, picked up costumed campers from their buildings and drove them to the patio. Each country or culture was announced with facts about that area as the campers performed an international fashion show for the audience. Ella sometimes invited parents or the media. The above picture shows the International Express delivering costumed campers. Below is the International Fashion Show complete with a camper leading Bullet, the donkey, and representing Mexico.

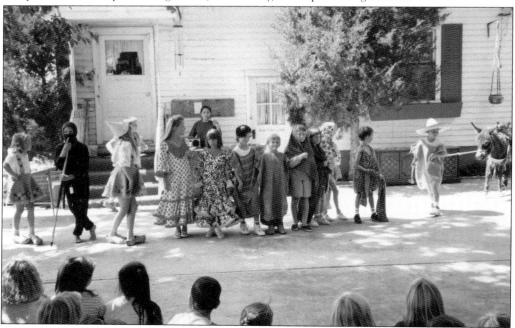

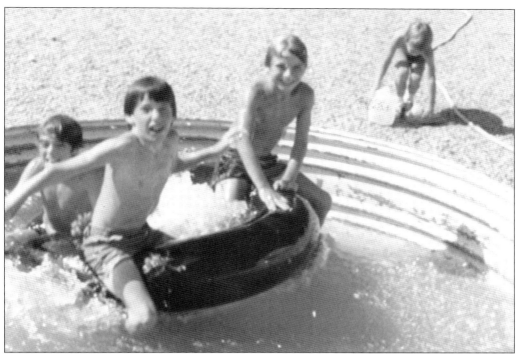

MOON FARM SWIMMING. In the early years of the day camp, a stock tank was filled with water for the campers to cool off. The above picture, taken around 1977, shows a tank with campers splashing around. In the 1980s, two wading pools were built. Campers between the ages of 8 and 12 enjoyed a larger pool, while the smaller pool was reserved for those under age 8. The below photograph shows the wading pools. Swimming lessons were also arranged with the City of Fruita for interested parents. Participating day campers were bussed to the Fruita pool each Friday morning for their hour-long lesson. Each instructor taught six to ten campers, depending on their abilities. Kids received certificates on the last day. This was such a popular activity that sometimes a bus and a van were needed for transportation.

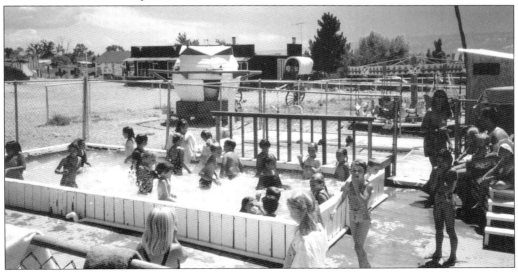

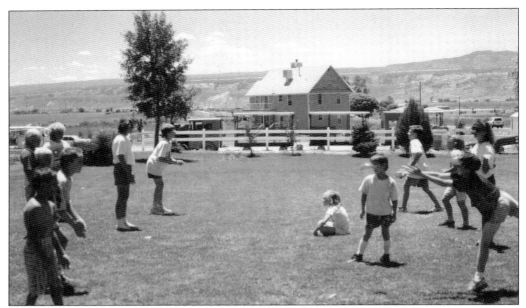

WATER BALLOON TOSS. For the water balloon toss, interested campers picked a partner and lined up across from their friend. The counselor gave one partner a water balloon, which they would toss to their partner. If the partner did not catch the water balloon, they were soaked and eliminated. When the whistle blew, participants would step back and toss again. This was repeated until the last pair remained, victorious and dry.

WATER SLIDES. Since the summer afternoons were hot in Fruita, water slides became a popular activity. This picture shows the metal slide being used as a water slide. Heavy plastic was placed at the bottom of the slide. The other type of water slide—used more often—was the same heavy plastic placed flat on the lawn. Water was sprayed on the plastic and the campers as they slid along it.

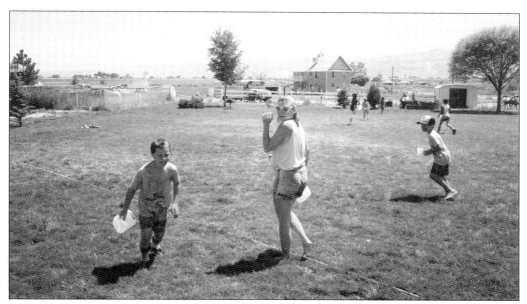

COOLING OFF. Other water activities at day camp included running through the sprinklers, water fights, and water-gun duels. This picture shows a water fight. A couple of times each week, the athletic director would organize water fights by filling a tank placed on each side of the athletic field. When the whistle blew, everyone got soaked. This was a camp favorite, and day campers loved it when counselors joined in.

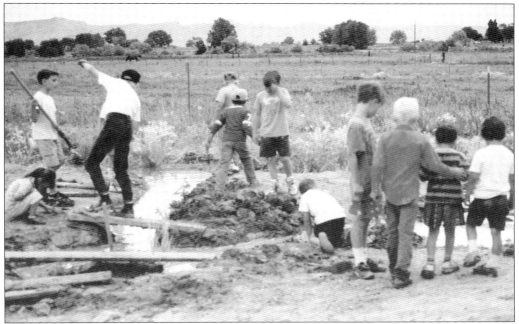

THE RIVER NILE. If campers were adventurous and had their parents' permission, they could play in a ditch behind the Egyptian area. Ella Moon called it the River Nile. More than one parent hesitated to write a note until they realized the River Nile was just a ditch where the campers could catch crawdads, make mud pies, or just pile up mud to make a dam.

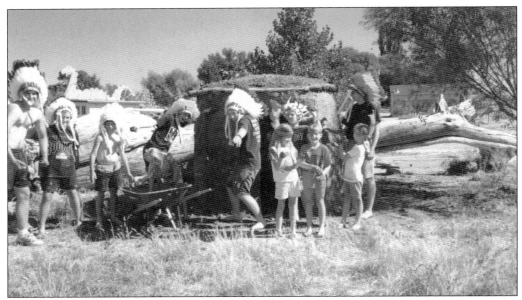

THE MUD HUT. The Navajo Mud Hut had to be fixed every few years. Ella recruited a counselor and older kids to help her. As with any chore around Moon Farm, Ella made it exciting. The mud, clay, and straw mixture was applied by hand, and the headdresses were used for fun. After the hut was fixed, campers were hosed off and given special milkshakes in her kitchen.

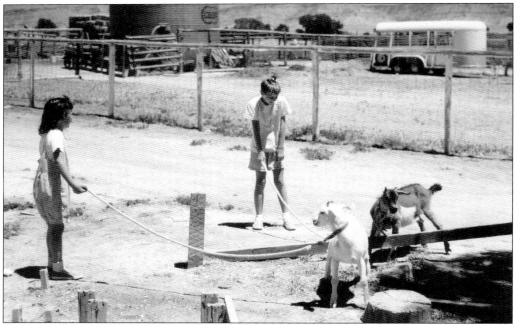

WALKING ANIMALS. It was not unusual to see day campers walking barnyard animals around the farm. Wallace Moon had different-sized harnesses for all his animals so that campers could walk them (with permission). Goats were always fun because they were so unpredictable, as shown here. Chickens were too small to walk, so day campers would chase and catch them, then carry them to their claimed forts for a visit.

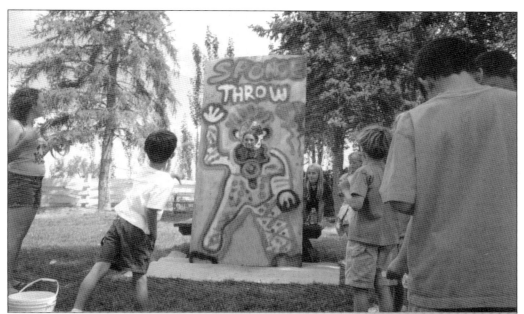

MOON FARM CARNIVAL. Each summer, a day would be set aside for the Moon Farm carnival. Counselors organized it in the morning before the flag-raising. The carnival would then take place from 10:30 a.m. to 3:00 p.m., with a lunch break at noon. Some of the exciting activities included a fishpond/fishing for toys, the dart throw/popping balloons, a sponge toss, a ring toss, face painting, and a haunted house in the farmhouse basement. David helped junior counselors make it spooky. Above, campers are participating in the sponge toss. Below, Greg McKee (left) watches Brendon Jens try his hand at the dart throw. Campers could earn tickets during the carnival and spend them in the afternoon. An assembly line of treats was set up in the garage for ticket redemption. Snacks included different flavored ice-cream cones, Popsicles, popcorn, and other treats.

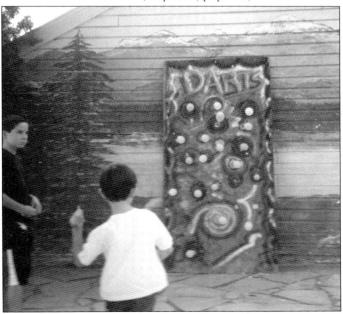

OLYMPICS OPENING CEREMONIES. The Moon Farm Olympics were held every summer. Each age group was designated a day to compete. Therefore, the Olympics stretched over seven days. The medalists from the prior day were given the opportunity to participate in opening ceremonies during flag-raising. Ella Moon created a pretend torch and painted the Olympic rings on a piece of material for the Olympic flag. The above picture shows Brittany Moon running the torch through a tunnel of cheering campers. The torch was placed in a metal holder for the day. Sometimes, an authentic 2002 Salt Lake City Winter Olympics torch was used, since it was displayed in the Mini Museum. The torch was on loan from Ella's niece Talitha Day. In the below picture, campers are shown running in with the flag to be raised on the pole while Olympics music played.

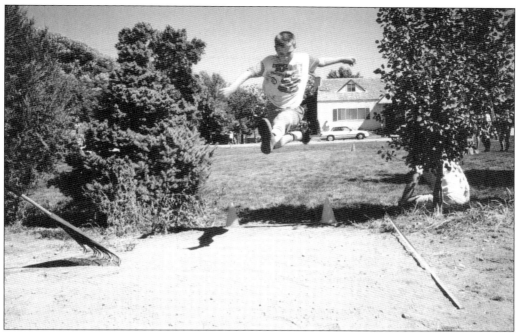

COMPETITIONS AND MEDALS. Day campers were excited to compete in the Moon Farm Olympics, where they would go up against boys or girls their own age. Campers could win gold, silver, or bronze medals. The medals were made in silicone molds created by David. Counselors poured plaster of paris into the mold and allowed it to dry. After the hardened medal was popped out, it was painted gold, silver, or bronze. A ribbon was tied on, and the winning camper's name was written on the back along with their event. Events included the 50-yard dash, basketball throw, long jump, obstacle course, and iron camper. The above picture shows a camper competing in the long jump. The day ended with a closing ceremony at which medals were presented by the athletic director, as shown below.

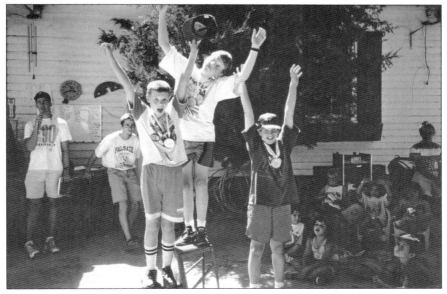

SPECIAL PRESENTATIONS. Campers enjoyed special presentations a few times each summer. These presentations covered various topics. Above, day campers are pictured in the tepee during a Native American presentation. Since Ella Moon's niece Renee Workman was the Fruita fire chief in the 1980s, the fire department occasionally came out for special safety demonstrations. Sara the Safety-Saur-Us was also used for a safety presentation, as shown below. Once, a professional mountain biker demonstrated his skills. He rode across a log and jumped his bike up the picnic table. Another fun presentation involved a dog trainer. The campers also loved when Peggy Malone led sing-alongs while playing her guitar during flag-raising. Ella scheduled many other special presentations over the 32 years of day camp.

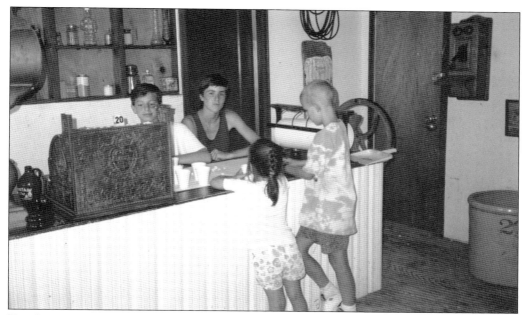

THE COUNTRY STORE OPENS. Throughout the day, campers had opportunities to earn tickets for things like participating in activities, walking the obstacle course without falling, helping counselors, and finding peacock feathers. These tickets could be redeemed in the Country Store after lunch. Junior counselors or older campers operated the store. Tickets could be traded for popcorn, Kool-Aid, Dum-Dums, or toys. Here, two junior counselors are helping campers redeem their tickets.

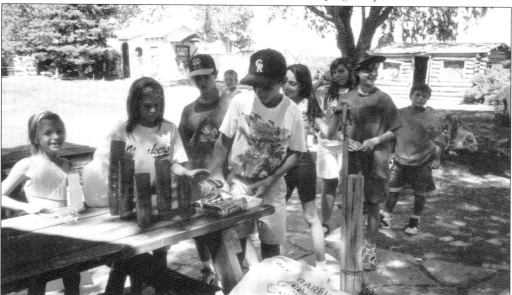

AFTERNOON SNACK. Following the afternoon train ride, campers gathered their belongings and headed to snack areas. Counselors served Kool-Aid and a cookie before walking their age groups to the back lawn for bus call. This picture shows 10-, 11-, and 12-year-old campers receiving their snack. During afternoon roll call, children would board the 4:30 p.m. bus, wait for the 5:30 p.m. bus, or stay at the farm.

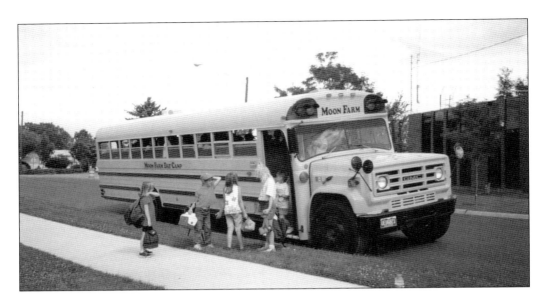

SHERWOOD PARK. Day campers were either dropped off and picked up at Moon Farm or transported to and from Sherwood Park in Grand Junction. After a full day of activities, many exhausted campers slept on the bus during the 25-minute ride. The above picture shows campers outside the bus. All campers walked to the shelter, because the sign-out books were on the picnic tables, as shown below. Day campers who were waiting for their parents to arrive were kept busy. Some drew and colored pictures. Others played kickball or a game called 500 on the field. Some campers were happy sitting under a shade tree and visiting with friends. Friendship bracelets and plastic key chains were also created at the park or taken home to finish.

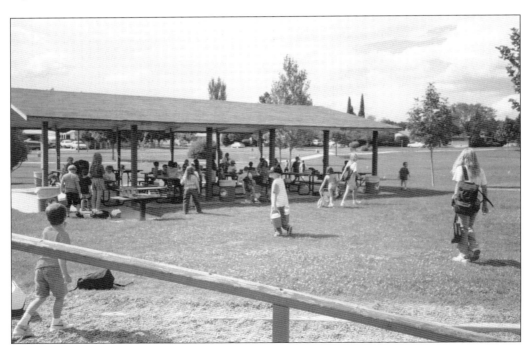

Six
Later Years

GRAND MESA. This picture of Ella and Wallace Moon was taken on the Grand Mesa in 1990. Unfortunately, Wallace passed away in 1995 and was not around during the later years of Moon Farm. The spring of 2008 brought many changes. After 32 successful years of running the day camp and Ella turning 90 years old, it was time to move in a different direction.

THE PUMPKIN PATCH BEGINS. After the day camp closed, Moon Farm was not generating enough money to keep it going through field trips, visitors, and birthday parties. David Moon envisioned a pumpkin patch to save the farm. He thought people would come in October to enjoy the buildings and petting zoo and purchase pumpkins. In the summer of 2011, David's idea was put into motion, and the pumpkin patch was born. Pictured above are Jannae (left) and David Moon (center) with Mary Joan Seal. Ella Moon (at far left in the below image) got to enjoy the first two years of the pumpkin patch before she passed away in 2013. She sat in her chair by the Swiss Chalet and watched people enjoy the farm or visited with friends who came out to see her, as shown below. (Above, courtesy of Denise and Steve Hight.)

Swiss Chalet Headquarters. As pumpkins grew throughout the summer, Halloween decorations were bought and collected. These were stored in the Swiss Chalet because it was closest to the field. This gave David an idea to use the Swiss Chalet as the farm's pumpkin headquarters. The area was decorated inside and out. When the time came for harvesting, many pumpkins were brought out of the field and placed on the lawn. It was beautiful and the perfect place to collect admissions and sell pumpkins. The above picture shows decorations outside the Swiss Chalet. The below image was taken inside the pumpkin patch headquarters. Small gourds, kettle corn, and T-shirts were sold in the office. It was heated on cold days so employees and visitors could warm up after searching for the perfect pumpkin.

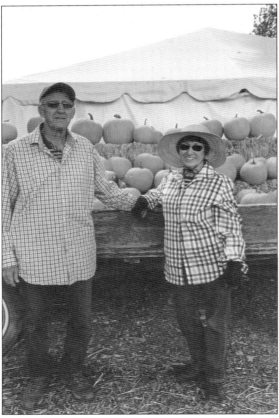

GROWING AND HARVESTING. The 2011 pumpkin patch started on a small scale. David Moon knew about farming but had never grown pumpkins. Seeds were ordered, and David read about pumpkins while also gathering advice from pumpkin farmers. He planted only one field. The field he chose was east of the tree row. The pumpkins grew, but they were sparse where shade from the tree row hit in the afternoon. David did not realize how important the afternoon sun was to help the pumpkins grow. A field behind the Swiss Chalet was used in 2012, and the east field (pictured above) was added the following year. Jannae Moon's parents, Bert and Paulette Jens, are pictured at left after cutting pumpkins. They were integral in helping harvest and stock pumpkins every year.

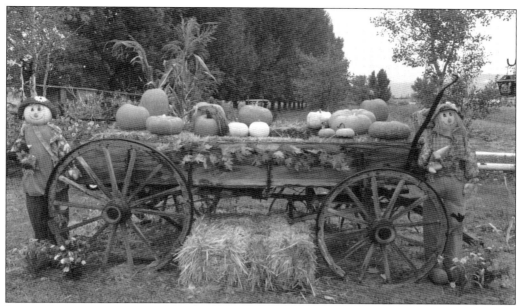

PHOTO OPPORTUNITIES. One of the more picturesque areas at Moon Farm Pumpkin Patch is shown here. A row of trees in the background turns brilliant yellow, making the fall scene gorgeous. Many families from the community posed for pictures during the 10 years the Moons ran the pumpkin patch. Other favorite places for photographs were near the Swiss Chalet and the antique hay wagon full of pumpkins.

CARVING PUMPKINS. Willy Tuz, owner of Colorado Fruit Designs, is a professional pumpkin-carver who frequently displayed his artistic skills at Moon Farm. Tuz dazzled visitors with intricate carvings and is pictured with his Yoda creation in 2017. He participated in a contest in which Facebook friends guessed what he would carve into the enormous Atlantic Dill. Tuz's talents earned him a spot on Food Network's *Outrageous Pumpkins* and *Halloween Wars*.

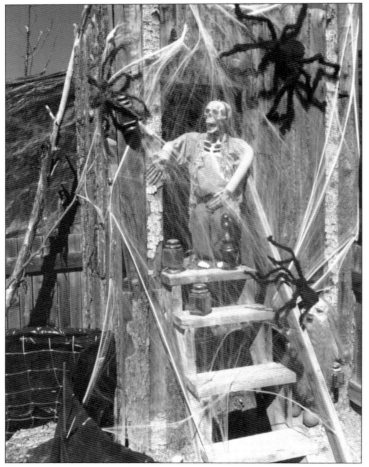

HAUNTED MAZE. David Moon transformed Fort Apache into a haunted maze. He parked the yellow school bus from Moon Farm Day Camp by the fort, as shown above. The bus became the entrance to the maze. Using the tractor, David moved numerous straw bales to create an elaborate maze. The bus, each fort, and rooms in the maze were themed. One scene in the fort is pictured at left. Visitors made their way through the bus to the fort and into the maze. More decorations and rooms were added each year. By 2020, the straw maze had grown to include different scenes, with music in each. There were also two haunted buses. A 1946 green school bus was added as an exit out of the maze.

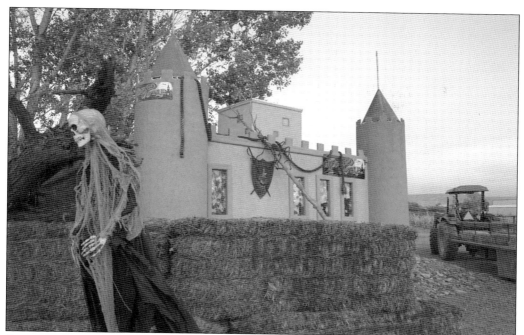

OTHER HAUNTED AREAS. A few years after the pumpkin patch began, haunted areas were expanded to a few buildings on the lower end of Moon Farm. Some were totally themed, such as the Spanish Castle, Egyptian house, and clown house. Others were slightly altered for October. This was a major undertaking. Decorating started at the beginning of summer so everything would be ready by October 1. The Spanish Castle (above) became a haunted castle complete with a creepy bride, a graveyard, and floating ghosts on the wall. The Egyptian Temple was transformed into Haunted Egypt. When visitors walked in, they were greeted by a motion-activated talking mummy. Many scary items were added to the showcase. The second room contained a fortune teller with a rotating head. Pictured below are Haunted Egypt and the Witch's House.

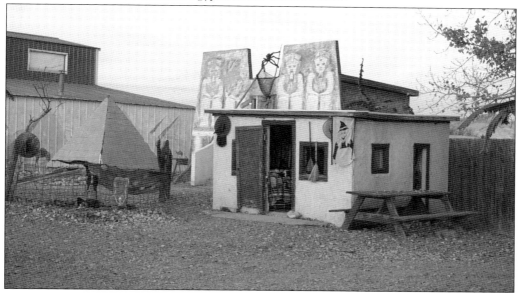

CORN MAZE. Since pumpkins did not grow very well east of the tree line, David Moon planted corn. A short, themed corn maze was cut into the cornfield for several years. It was adorned with scarecrows, a troll village, and a haunted trailer. The Moon Farm train was also decorated and placed next to the corn maze. This picture shows the witch in the corn.

KIDS' STRAW MAZE. When David had extra straw bales, he made a small maze for younger children to enjoy behind the castle. It was decorated with props and short enough for parents to watch their little ones navigate through it.

ANIMALS AT THE PATCH. Moon Farm always had a petting zoo and rabbit valley (pictured at right). David added more animals for the annual pumpkin patch, such as a calf, baby pigs, lambs, and baby goats. He also made sure there was a pony and, of course, Bullet the donkey. A fun addition were three alpacas placed in a pen near the entrance; they were on loan from Suncrest Orchard Alpacas.

FUN HAYRIDES. Visitors could ride the hay wagon down the pumpkin patch, following over 20 cottonwood trees to the bottom field and back. There was never a schedule for the hayrides. David Moon gave rides whenever one was requested, which was often. In fact, the tractor ran nonstop on busy weekends, and additional drivers were hired on those days.

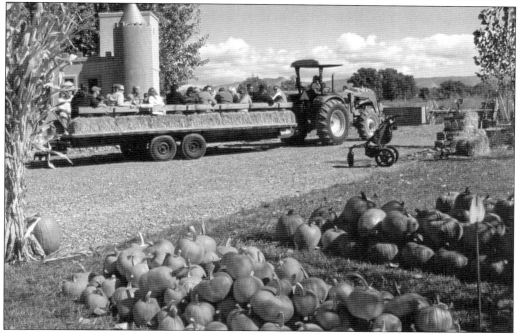

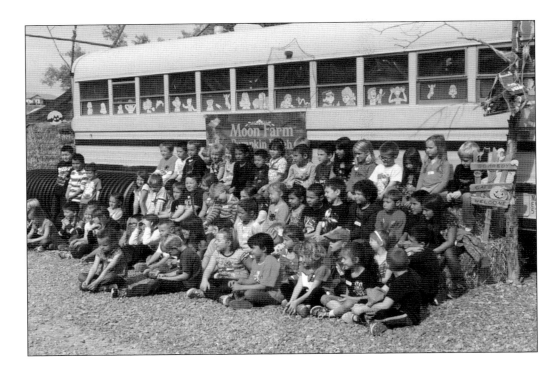

SCHOOL FIELD TRIPS. Weekdays were normally booked with field trips. The charge was only $5 per child. The price included admission to all of Moon Farm, the petting zoo, haunted attractions, and a small pumpkin. David drove the tractor pulling a hay wagon full of children to the kids' patch. He normally gave them a short talk about pumpkins and let them choose one to take home. Taking a class photograph next to the school bus was a must, as shown above. The below picture shows a class picking out pumpkins to take home.

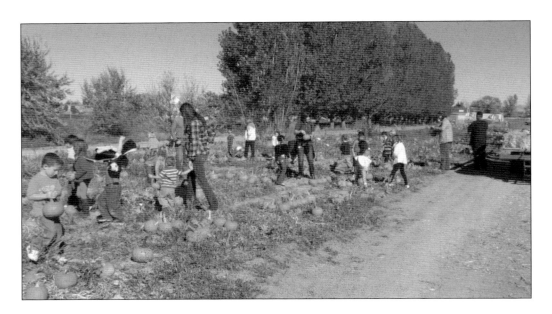

FRUITA FALL FESTIVAL. A fall celebration has taken place in the town of Fruita since 1914, when it was a cowboy reunion featuring horse races, bull-riding, roping, and bucking contests. Women showcased crafts, fruits, jams, and baked goods. A night dance would conclude the festivities. After the 1950s, this Cowpunchers' Reunion evolved into the Hunter's Roundup, a celebration to begin hunting season. In the 1970s, it was renamed the Fruita Fall Festival. The picture at right displays a photo booth decorated by Moon Farm. The picture below shows David Moon as grand marshal of the 104th annual Fruita Fall Festival Parade in 2018. The carriage and horses pictured are used for the grand marshal in the parade each year thanks to Absolute Prestige. (Right, courtesy of Jennifer Seal.)

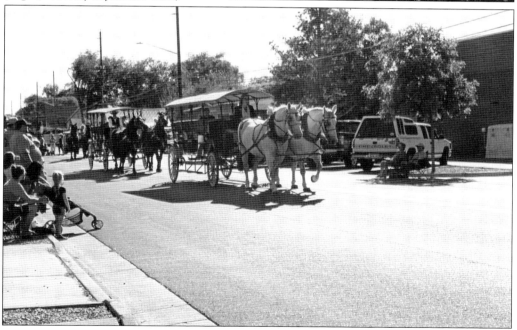

VACATION RENTALS. Moon Farm is not limited to locals. Families from across the United States enjoy Moon Farm by renting one of two vacation rentals on the property. Groups of all sizes book the resettlement-era farmhouse. Ella Moon enjoyed entertaining and would have loved opening her home for all to experience. The above picture shows Big Agnes tents in the foreground and the farmhouse vacation rental in the background. Representatives from Big Agnes booked the farm in the fall for many years. They set up a tent exhibit in the field and stayed in Moon Farm's vacation rentals. The below photograph shows participants in a Rocky Mountain Bikes' bike launch at the farm. The vacation rental business started in 2013 and is still operating today under the new ownership of Grand Valley Equine Assisted Learning Center.

NEW OWNERS. In 2018, after over 60 years of operations, the Moon family decided to sell Moon Farm. The nonprofit Grand Valley Equine Assisted Learning Center (GVEALC) was interested in buying the property. GVEALC provides horse-based therapies to children and adults who are disabled or have special needs. Moon Farm was a perfect fit. It offered the space necessary for equine therapy, and the revenue derived from the vacation rentals and pumpkin patch could support the therapy operation. Since GVEALC is a nonprofit, it conducted several fundraisers to help purchase the property. The above picture shows phase one of the brick fundraiser sponsored by the Brickyard; Carlson Memorials, Inc.; and the Moon family. GVEALC purchased Moon Farm in July 2021. The ribbon-cutting is shown below. (Below, courtesy of the Fruita Chamber of Commerce.)

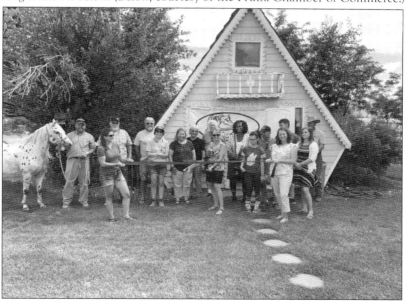

Discover Thousands of Local History Books Featuring Millions of Vintage Images

Arcadia Publishing, the leading local history publisher in the United States, is committed to making history accessible and meaningful through publishing books that celebrate and preserve the heritage of America's people and places.

Find more books like this at
www.arcadiapublishing.com

Search for your hometown history, your old stomping grounds, and even your favorite sports team.

Consistent with our mission to preserve history on a local level, this book was printed in South Carolina on American-made paper and manufactured entirely in the United States. Products carrying the accredited Forest Stewardship Council (FSC) label are printed on 100 percent FSC-certified paper.